THE PAINTINGS AND THE JOURNAL OF
JOSEPH WHITING STOCK

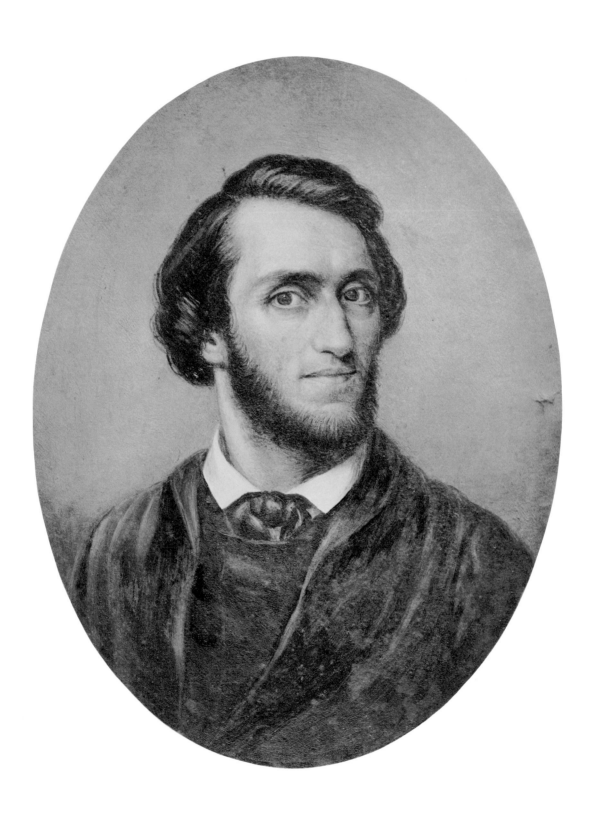

THE PAINTINGS
AND THE JOURNAL OF
Joseph Whiting Stock

EDITED BY

Juliette Tomlinson

WITH A CHECKLIST OF HIS WORKS

COMPILED BY KATE STEINWAY

Wesleyan University Press

MIDDLETOWN · CONNECTICUT

FRONTISPIECE:
Joseph Whiting Stock: self-portrait [I:20], February 1842.
Connecticut Valley Historical Museum, Springfield, Massachusetts

*The publisher gratefully acknowledges
the support of the publication of this book
by the Connecticut Valley Historical Museum,
from the Horace Moses Fund*

Library of Congress Cataloging in Publication Data

Stock, Joseph Whiting, 1815-1855.
 The paintings and the journal of Joseph Whiting
Stock.

 Bibliography: p.
 Includes index.
 1. Stock, Joseph Whiting, 1815-1855.
2. Portrait-painters—United States—Correspondence,
reminiscences, etc. 3. Primitivism in art—United
States. I. Tomlinson, Juliette, 1921-
II. Title.
ND1329.S69A25 759.13 [B] 76-7189
ISBN 0-8195-4098-6

CONTENTS

The artist's signature on reverse of self-portrait (cf. Frontispiece).

PREFACE

Although many well-known collections of American folk art include paint-
ings by the nineteenth-century artist Joseph Whiting Stock (1815–1855),
little is known about him, and most of what is known comes from an incom-
plete journal written by the artist sometime after 1846. This journal, tran-
scribed from the seventy-three-page manuscript and printed for the first time
in this book, is a curious combination of autobiography, diary, and account-
book. In it the artist condensed a great deal of information concerning his
early working years and listed nine hundred thirteen examples of his works.
But the journal ends nine years before his death, and to reconstruct the out-
lines of his later life one must go to the few other papers and to various news-
paper advertisements and notices of the period.

What impelled Stock to begin such a meticulous journal at the age of
thirty-one remains unknown. It is probable that he had earlier kept other
records, which were lost during his many journeys or somehow destroyed
and that the remaining one was an attempt to recapitulate material from the
others — probable because in the back of one of his miniatures a piece of a
page from another journal has been found. What happened to the others
must remain conjecture at this point.

The journal remained in the Stock family for many years after his death.
Some twenty years ago, before their deaths, Lucy Stock Halpenny and her
sister Mabel Stock Irwin, great-grandnieces of the artist, gave it and four
portraits and two miniatures to the Connecticut Valley Historical Museum
in Springfield, Massachusetts, the artist's birthplace. With the exception of
the journal there remain only a single letter of Stock's, his will, and the
known paintings, one hundred three in number, of which three have been
lost in this century. With the more than nine hundred works listed in the
journal and others signed and dated after 1846 or included in the inventory
of his estate, Stock must have painted more than a thousand portraits during
his relatively short lifetime. The one hundred paintings illustrated in this
book represent therefore only about a tenth of his work, and the chances of
locating as many more seem remote.

Virtually nothing has been written about Stock. In 1938, the late John
Lee Clark, then Director of the Springfield Museum of Fine Arts, published

an article in the magazine *Antiques*. A few years ago, Paul Rovetti, Director of The William Benton Museum of Art at Storrs, Connecticut, chose to write his master's thesis on the artist. In it he reproduces portions of the diary and gives a checklist of known paintings, which was the basis for the one in this book. I am very grateful to Mr. Rovetti for sharing his knowledge with me.

Work on this publication began several years ago, when the diary was transcribed by Sara McGreal Brownlee, who worked at the Museum one summer. Her transcription was read against the original manuscript to ensure accuracy. Later Carlo LaMagna did research on the artist's career and brought new facts to light. Without this work it would have been impossible to put together the portions of this book.

The checklist was compiled by Kate Steinway, who included as many portraits as could be identified. She succeeded in locating some portraits that had vanished, but others remain undiscovered. The final decision about those to be included in the checklist has rested with me, after consultation with Miss Steinway. Mary C. Black, Curator of Painting and Sculpture at The New-York Historical Society, has been most helpful with her suggestions about the artist's later career.

From the time that he was eleven, Joseph Stock was a cripple. He describes his infirmity in detail in the diary. One of his physicians, James Swan, wrote an article on the case in the March 1840 issue of *The Boston Medical and Surgical Journal*. This article and other medical information was brought to my attention by Dr. Howard Simpson. His advice and suggestions about the practice of nineteenth-century medicine have been most helpful for understanding the handicap with which Joseph Stock lived.

This book is the result of the cooperation of many individuals. I wish to thank Cecelia F. Callazzo, who so ungrudgingly typed many drafts of this material. Without their enthusiasm and help, it would have been impossible to complete. I hope that it will add to our knowledge of Joseph Whiting Stock. One must realize that, no matter how many examples are listed in the checklist, more will be discovered. No matter how much biographical material is included, new leads will appear. Questions will be asked as to what happened to the anatomical drawings and landscapes, which are listed but not located. These cannot be answered at present, but in the future they will be. What I have tried to do is to break a path, which will, I trust, lead others to further discoveries.

A BIOGRAPHICAL NOTE

Joseph Whiting Stock was born January 30, 1815, the third of twelve children of John Stock and his wife Martha Whiting. He had a normal childhood until an accident at the age of eleven paralyzed him from the waist down, confining him to bed. It was one of his physicians, a Dr. Loring, who suggested he take up painting and arranged for him to have lessons from Franklin White, a pupil of Chester Harding. It was another doctor, James Swan, who later would commission the artist to execute some anatomical illustrations for his temperance lectures, who contrived a method so he could move about.

In an article written in *The Boston Medical and Surgical Journal* in 1840 Dr. Swan described in detail his patient's physical condition. He mentioned that he first saw him in the summer of 1834, eight years after the accident. The doctor wrote that "his knees were bent at acute angles" and that "he had lain almost constantly in one position." He spent most of his time in painting and music and "had become quite proficient in these branches of education." He records that Stock had not stirred from his room for several years. To remedy this, Dr. Swan, aided by two first-rate mechanics, adapted a chair for the artist's use. It was a different design from those generally used, and it had several features to keep the artist comfortable. "In the case of Mr. Stock the abdominal belt was dispensed with, and subsequently the knee band, as he had so far improved in muscular motion that he could dress himself and get into his chair from his bed without assistance, and go all over the floor of the house." Dr. Swan's adaptation opened up a whole new world for Joseph Stock. Not only could he move freely about the house, but his conveyance could be put onto a railway carriage, making it possible for him to travel.

Stock's early attempts at portraiture were primitive. He related in his journal that his first work was of his sister Eliza and that it was a good likeness. As news circulated that the young artist had talent, he began to receive commissions from those who found his prices reasonable. After he adjusted to his wheelchair, his world became less circumscribed, and his first journey in 1836 took him to Wilbraham, Massachusetts. This was the start of a series of journeys that took him away from Springfield.

In 1838 he established a studio in a building on Elm Street, facing Court Square. It was not until 1840 that he made a long trip, when he went to New Haven, approximately sixty-five miles distant. In spite of his handicap he was able to make this type of trip with comparative ease. His chair was placed either on a private conveyance or a railroad car, and it was in this manner he left Springfield in 1841 for Warren, Rhode Island. Later on he made other journeys to towns in Connecticut and Massachusetts, setting up a studio in each place he visited and working there for a short period.

Tragedy seemed to stalk Joseph Stock during his lifetime, and in 1839 he was badly burned while making varnish. He recovered, but an attack of fever threatened his life. When he recuperated, it was discovered that he had a large ulcer on his right side and that the infection had spread to the hip bone. This problem proved too difficult for Dr. Swan, and another physician, Dr. Flint, was consulted. It was decided to operate. The head of the thigh bone was removed, an operation that would be considered major surgery today. To have a patient survive this operation one hundred years ago was little short of a miracle. In his article Dr. Swan concludes that Stock's case has been "one of a very interesting character, forcibly illustrating the tenacity of life, where organic functions are unimpaired, even where there has been great loss of power in the nerves of motion and sensation."

With the invention of the daguerreotype in France, a new element came into competition with the folk artist. It was introduced into this country by Samuel F. B. Morse in 1839, and its use spread rapidly and many of the itinerant artists felt its effect. Here was a process that reproduced a person's likeness without the long wait it took for the artist to paint a portrait. Daguerreotypes were not instant photography, but there was no question that the results were more accurate. Thus in 1844, Stock and his brother-in-law Otis Cooley set up a partnership in Springfield where they advertised portraits and daguerreotypes. The partnership did not last long, and Stock began to travel again.

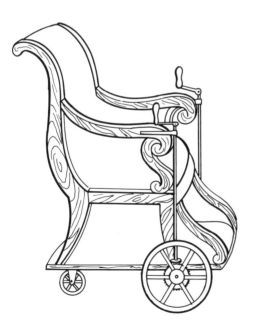

The wheelchair designed for Joseph Whiting Stock by Dr. James Swan: illustration from Swan's article in *The Boston Medical and Surgical Journal*, 25 March, 1840, redrawn for the present volume by Wadworth Hine.

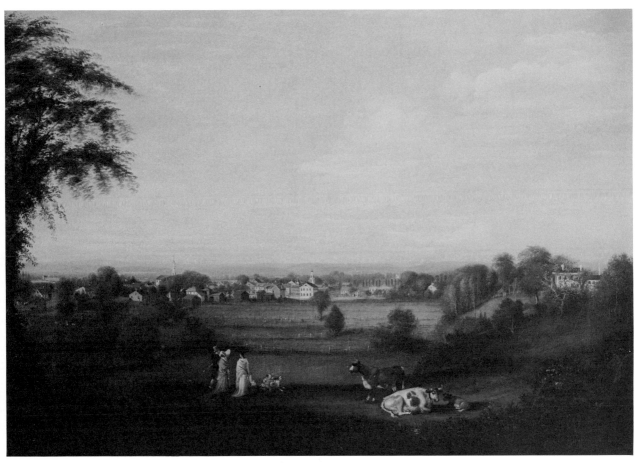

View of Springfield in 1824, by Alvin Fisher.
Connecticut Valley Historical Museum, Springfield, Mass.

It is not always easy to determine exactly where he lived and worked after August of 1846, when the journal ends. The Springfield City Directory for 1847 listed Stock as a portrait painter with rooms on East State Street over Stocking and Cate's Grocery Store. In May of 1847 Stock was in New Bedford, where he painted Captain Stephen Christian in May of that year, a work he signed and dated. Because there is no listing for him in the 1848 Springfield Directory, it may be assumed that he extended his stay in New Bedford. When his brother-in-law opened his Hampden Daguerrean Gallery in new quarters later that same year, Stock is mentioned as having rooms directly above the gallery where he would do "orders for Portraits, Landscapes, Banners &c. warranted satisfactory in every respect." It is evident that Stock's position with his brother-in-law had gradually decreased, for since 1846 he had not been listed as a partner. This was undoubtedly

due to his trips, and even in his last listing in the Springfield Directory in 1851–52, he is mentioned alone as a "portrait painter" with rooms in the Foote Block. It is not until the administrator's account of his estate that there is a clue to his whereabouts during the years prior to his death in 1855.

During these remaining years, he lived and worked in three towns in Orange County in New York. The first was Middletown, in which he settled sometime in May of 1852. Then he moved to Goshen a year later and finally to Port Jervis, his last residence. What prompted the artist to move to Orange County will probably never be fully determined. Between 1840 and 1860 there was a steady industrial growth in this section of the country. Two of these towns were manufacturing centers, and the advent of the railroad made them more accessible. Just as Joseph Stock had gone to New Bedford in the 1840s, attracted by the promise of patronage there, he, no doubt, had similar hopes when he decided to migrate to Orange County.

In the May 27, 1853, issue of *The Independent Republican*, published in Goshen, Joseph Stock advertised as follows:

> *PORTRAIT PAINTING.* J. W. STOCK would announce that he has taken rooms in VAIL'S BUILDING, opposite Edsall's hotel, near the depot and respectfully offers his professional services to the public. He has during the past year painted over sixty portraits in Middletown, and having devoted his time for twenty years in the study and practice of his profession in New England towns and cities, feels confident of giving entire satisfaction to his patrons. Terms moderate. Give him a call and see specimens. Gilt frames of all kinds, canvass, artist's colors, and brushes for sale and furnished to order. Goshen, May 18, 1853.

The mention of his having done sixty portraits in Middletown during the previous year would indicate that he arrived there in May of 1852. This would coincide with his last entry in the Springfield City Directory for 1851–52. Prior to Christmas in 1853, Stock inserted another notice in the newspaper which was more ambitious than his first. He mentions having painted several "fine landscapes, Portraits of George Washington, Daniel Webster, Henry Clay." He also advertised that he sold ornamental shell work consisting of "Work Boxes, Card Baskets, Frames and splendid Clocks." They would make excellent gifts for the holidays. In later notices he mentions that he kept a good supply of artist's colors, brushes, and can-

vas and that he cleaned and varnished oil paintings. It was not until June of 1854 that he advertised he had engaged rooms in Port Jervis, to which he shortly moved.

When Stock moved to Port Jervis, he acquired a partner, S. W. Corwin, and they advertised as having a studio in Fowler's Brick Building. Later they moved to a different location in Port Jervis, Lockwood's Hall, which was located on Pike Street. A check of the newspaper files indicates that their partnership lasted until September 15, 1854, when their last notice appeared. Little is known about Salmon Corwin except that his obituary mentioned that he was an assistant to Joseph Stock when he lived in Goshen. He died a few months after Stock at the age of twenty-six. At least two examples of his portraits have survived. During his association with Stock, he was responsible for the handsome view of Port Jervis "From the Mountain on the Pennsylvania side of the Delaware," which was published by Endicott and Company in 1854. In the inventory of Stock's estate one hundred thirty-two engravings of Port Jervis, some of them colored, are listed, and what is referred to as a "View of Port Jervis, (partly finished)," was included in the appraisal. Perhaps this work was similar to the one done by Corwin, or Stock may have done another on his own. Their partnership was short-lived, for in a letter he wrote to Otis Cooley in January of 1855, Stock mentions that his business had improved since he bought Corwin out.

In October of 1854 Joseph Stock returned to Springfield to draw up his will. After he did this, he went back to Port Jervis with the intention of leaving in the spring of 1855. What was to be his final illness attacked him when he was still in that town, for his executor paid a Dr. Dufrene of Port Jervis $20.95 for his "last sickness." Undoubtedly, his plans for his return to New England included eventually living in Springfield, for he planned to remodel the house he owned where his father lived. These did not materialize, for the Goshen *Democrat & Whig* recorded on July 13, 1855: "June 28 — At Springfield, Mass. J. W. Stock, artist, late of Port Jervis, aged about 37 years old." *The Independent Republican* earlier the same month recalled that he was "a portrait painter of superior merit, and his other many virtues and accomplishments as a gentleman and a scholar secured him, during his brief sojourn among us, many warm friends." *The Springfield Republican* in its notice mentioned his lifelong affliction and concluded that "he was best known through his paintings, and these will long preserve an agreeable, though saddened memory of him."

In his journal Stock used a letter code to show the prices he charged for his work. It is based on the letters of the alphabet from A to O. It is assumed that A stands for one and O indicates zero; thus A noted in the margin of the diary after a painting would signify a charge of one dollar, and E would indicate five dollars. When the letters are combined as in AO, the amount would equal ten dollars; or as in AH, eighteen dollars. The letters which appear most often in the journal either singularly or in a combination are AO, H, E, and G. The average price for a painting was between five and ten dollars. His canvas sizes varied, but thirty by twenty-four inches seemed to be the standard portrait size. Those sold during his early career for between two and six dollars, and later on he asked ten to eighteen dollars for them. Larger sizes were more expensive. A "whole figure," sixty by forty-two inches, done in 1838 of Miss Ann M. Haynes cost twenty-five dollars. The largest canvas he recorded in the diary was of A. Goodale of Amherst, painted later the same year with dimensions of sixty-six by forty-two inches, for which he was paid twenty dollars. For some reason, the portrait of Willard Sears, painted in New Bedford in 1842, cost fifty-five dollars even though it was of the same size as Mr. Goodale's. Perhaps it required repainting before it was satisfactory to the sitter.

The anatomical sketches that Stock did for Dr. Swan brought seventy-five dollars, and later the doctor paid another twenty dollars for two drawings of skeletons. His "Fancy Pieces" commanded prices between six and ten dollars, and sometimes instead of cash he took pay in trade. This happened in the case of J. Ward, a tailor in New Bedford, who provided the artist with goods in return for his mother's portraits. Though he had only a few pupils during his career, in 1844, he taught W. K. Plummer for "three months — $50" and noted EO in the margin beside the entry. This would confirm the accounting system he used throughout the journal. When the journal figures are totaled, they come to six thousand dollars, which was a good income for that time.

What was it that made Joseph W. Stock important as a nineteenth-century folk artist? Most significant was his ability to overcome a physical handicap that would have immobilized a man of lesser character. The fact that he valued his work highly enough to keep a diary indicated he did not wish to be forgotten. Certainly, he must have pleased his sitters or they would not have flocked to his rooms to pose. A characteristic which stands out in his work is his ability to capture small details which draw attention to the painting—the inclusion of chairs, draperies, books, hats, and

various animals. By examining his work closely, a great deal may be learned about nineteenth-century daily life: how children were dressed; what types of furniture were found in houses; whether rugs were plain or decorated. The majority of his work is not stereotyped; instead it is quite distinctive, especially in his later works which show a sureness not present before. There is no question that Stock was a versatile artist. Though his technique was not as finished as some of his contemporaries, he portrays his sitters with a sense of style that gives his paintings a distinction of their own.

THE JOURNAL

OF JOSEPH WHITING STOCK

Journal as kept by
Joseph W. Stock

It being my intention, henceforth, to keep a brief journal of my life and business.* I shall, to make it complete, prefix a short sketch of my early life and success in my profession up to this time.

I was born in Springfield, Mass. Jan. 30th, 1815. My parents, were poor, married early, and have had a large family to support, but have ever maintained a respectable standing in society by their honest and industrious habits. My father has been employed in the U. S. Armory, ever since his removal to Springfield which occurred a short time previous to my birth.

My early years were spent like those of most boys of the same age, in attending the common schools, and play. and I recollect no event worth mentioning here previous to the accident which rendered me a cripple, and influenced my course through life.

On Sunday April 9th 1826, my brother Isaac, Philos B. Tyler, and myself were standing near the body of an ox-cart which leaned nearly upright against the barn very intently engaged in conversation, when suddenly, I percieved it falling, which instead of endeavoring to avoid, I attempted to push back and was crushed under it. The boys unaided lifted the cart and drew me from under it. I experienced no pain at the time and no other sensation than a heaviness and prickling numbness in my legs, which were powerless and led me to exclaim that they were broken.

My mother was soon called (father was gone to meeting) who carried me into the house where all the Medical Men in town were soon gathered and at once pronounced it to be an injury of the spine, caused by a laxation of the last dorsal from the first lumber vertebra which wholly destroyed all the nerves proceeding from the spinal chord below the injury, and consequently destroyed all action and sensation in the lower extremities, from the hip downwards. It was set three times within a week, but it was impossible to keep it in its proper place while the joint had time to reunite. For several

* Stock's journal has been transcribed with no editing other than the addition, within brackets, of some names and an occasional word. No attempt has been made to correct his grammar or punctuation or spelling. The few changes made involved only the paging and spacing of the work, and even these remain true to his own style. The page numbers of the journal are given in brackets in the margins.

Journal
as kept by
Joseph W. Stock

It being my intention, henceforth, to keep a
brief journal of my life and business, I shall,
to make it complete, prefix a short sketch of my
early life and success in my profession up to this
time.

I was born in Springfield, Mass. Jan. 30th, 1815.
My parents, were poor, married early, and have
had a large family to support, but have ever main-
tained a respectable standing in society by their honest
and industrious habits. My father has been employed
in the U.S. Armory, ever since his removal to
Springfield which occurred a short time previous to my
birth.

My early years were spent like those of most boys of
the same age, in attending the common schools, and
play, and I recollect no event worth mentioning here
previous to the the accident which rendered me a
cripple, and influenced my course through life.

On Sunday April 9th 1826. my brother Isaac, Philos B.
Tyler, and myself were standing near the body of an
ox-cart which leaned nearly upright against the barn
very intently engaged in conversation, when suddenly

Opening pages of Stock's *Journal*

I percieved it falling. which instead of endeavoring to avoid. I attempted to push back and was crushed under it. The boys unaided lifted the cart and drew Me from under it. I experienced no pain at the time and no other sensation than a heaviness and prickling numbness in my legs which were powerless and led me to exclaim that they were broken.

My Mother was soon called (father was gone to meeting) who carried Me into the house where all the Medical Men in town were soon gathered and at once pronounced it to be an injury of the Spine, caused by a luxation of the last dorsal from the first lumber vertebra which wholly destroyed all the nerves proceeding from the spinal chord below the injury, and consequently destroyed all action and sensation in the lower extremities, from the hip downwards. It was set three times within a week, but it was impossible to keep it in its proper place while the joint had time to reunite. For several weeks I suffered much pain from the injury and also from the confined and unchangeable position which the nature of the injury required during the process of Nature for rejoining and strengthening the wounded part. My constitution was so much weakened and exhausted by these efforts and the profuse suppuration from ulcers which had formed on my hips as to

weeks I suffered much pain from the injury and also from the confined and unchangeable position which the nature of the injury required during the process of nature for rejoining and strengthening the wounded part. My constitution was so much weakened and exhausted by these efforts and the profuse suppuration from ulcers which had formed on my hips as to induce symptoms of hectic [fever] and mortification and for many months my friends dispaired of my life. But the unceasing care and attention of my parents and physician (Dr. Loring) aided by a naturally robust constitution finally overcame the disease and I was restored to comparatively good health.

I was confined almost constantly to my bed only while it was being newly made and changed my father held me in his arms or laid me on another bed. Many eminent surgeons visited me and examined my injury but gave no encouragement of a recovery and I became cheerful and contented in my situation, amusing myself in a variety of ways. Sometimes by reading, studying, sewing at other times by indulging my Yankee propensity for whittling and making toys for the children. My friends often consulted and inquired for some occupation by which I might gain a livelihood but my situation made me incapable of following pursuits by which most men gain a living.

My attention at length, was directed by a friend, (Dr. Loring, who I shall ever remember with grateful feelings inspired by his uniform kindness and attention during my sickness and confinement.) to the art of Painting which he thought I might easily attain and support myself by painting portraits.

This was in the fall of the year 1832, when I commenced. Mr. Franklin White, a young artist, pupil of Chester Harding, called upon me frequently and showed me his manner of preparing and laying the pallet and lent me some portraits to copy. I followed this course some months when I attempted my sister Eliza's portrait and made so good a likeness as to induce my friends to encourage me by their patronage. It was soon noised abroad and received many visits from citizens and some orders which were executed with various degrees of success like the productions of all beginners. My terms were very low and many were induced to patronize me from benevolent motives and as I gained more experience from observation, and the patronage thus bestowed upon me I soon acquired more skill and expertness in the use of the pencil and gave more perfect likeneses. I painted some portraits for people from the neighboring towns and frequently received invitations to make them a professional visit but my situation prevented. About

this time (1834) Dr. Swan removed to S. and had occasion to call upon me to excute some anatomical illustrations. He became at once interested in trying to remedy the inconvenience resulting from the injury, and long confinement to the couch in nearly the same position. Several attempts had been made to construct something by which I might be enabled to sit up which had failed of accomplishing the desired effect and my friends had become discouraged from any further attempts, when Dr. S. submitted his plan. It met with but little favor at first and he had many difficulties to contend against in developing and maturing his plans for my relief. He however, by dint of perserverance succeeded in constructing a chair which answered all our expectations. I was soon enabled to sit up several hours in the day and could roll myself all over the same floor of the house.

My health improved and in the spring of 1836 I left my father's house for the first time at the invitation of several friends in North Wilbraham who wished their portraits painted and thought there might be many others who would be induced to patronize me after seeing theirs finished. Accordingly I took a room near the Academy and my success was such as to equal my most sanguine expectations and their kind and generous encouragement in this my first professional excursion has left indelible impresion on my mind that all the kindness and success which has invariably attended my labors in the other towns has failed to efface. I have visited W. several times since also Cabotville, Stafford, and some other towns which will be mentioned in their proper place.

I was very well patronized and was doing a very good business when all my plans were frustrated and my life endangered for a time

On the evening of the 1st of Jan. 1839 I was preparing some mastic varnish and was in the act of turning it off while hot when it took fire from the light and communicated to my dress and I was soon involved in the flames. It was soon extinguished but hands, face and neck, were badly burned, so that at the time my physician thought me in considerable danger. I was recovering rapidly from the effects of the burns, which were nearly healed when on the 17 of Jan I was attacked with a fever which endangered my situation very much. As the fever yielded to the skillful treatment of my physician another and more formidable difficulty appeared. My right hip had never become perfectly sound since the formation of the ulcer during the sickness arising from the first injury of the spine, This had now become so large, and suppuration so profuse, as to render my case dangerous. There was a spontaneous laxation of the hip-joint, the ligaments destroyed and the

bones in a degree carious. My constitution had become much wasted by the fever and suppuration produced some tendency to hectic.

At this juncture, my friends becoming alarmed my physician (Dr. Swan) requested counsel. Accordingly Dr. Flint, was called who considered me in a very critical situation. He advised more active and stimulating medicines to sustain and increase my strength. This treatment was followed for a short time without much perceptible benefit, and it was finally resolved to remove the diseased bones. The head of the thigh-bone was sawed off and diseased parts of the other bones removed. The operation was performed by Dr. Flint.

After the removal of the bones, I began very slowly to recover. The cavity gradually filled up but it was a long time before it had healed perfectly sound as it now is.

My physicians said the opening and suppuration of the hip-joint would under most circumstances, prove fatal. In my case not only the head of the thigh-bone but also a portion of the other bones, was carious, exfoliated and came away: and yet under all these unpromising circumstances, I recovered Thanks to a Kind Providence and the skill of the attending physicians.

It was many months before I was enabled to resume the labors of my profesion and more than a year before I completely recovered. During this time I painted very little and remained at home excepting a short visit to Cabotville to finish some portraits begun before my illness.

Having noticed the principal events in my life unconnected with my profesional history I will now record the amount of my labors up to this time; mentioning the names, where painted and giving the date as near as I can remember.

		age years	size Inches*	
[8]	1832 Baltimore Lady	copy	22 x 27	
	Boston Lady	"	24 – 30	B
	Lucinda Sackett	"	" "	C
	Wm. B. O. Peabody	"	" "	E

* Throughout the account-book section of Stock's journal he regularly used three columns ruled off to the right of the page to record various information. The first column was for the age of the sitter; the second for the dimensions of the painting; and the third for the price that he charged, given in his alphabetical code, which is explained in the editor's biographical note.

		Yrs				
The Toilet (Fancy piece)	"		" "	F		
Simon Sanborn	"		" "			
C. B. Stebbins	"		20 – 24			
Elisha Tobey	"		21 – 26			
1833 Amelia (Fancy piece)	copy		24 – 30	E		
Young Napoleon.	"		" "	E		
John Randolph	"		21 – 26	E		
		Yrs			[9]	
Eliza J. Stock my sister aged		9	20 – 24			
J. Madison Fletcher	"	20	24 – 30			
Portrait of Napoleon	copy		25 – 30	E		
" " Josephine			" "	F		
Dr. Wm. L. Loring		40	" "			
Charles Noyes		4	36 – 46	G		
The Twins (fancy piece)			30 – 36	A.B.		
Mary A Sage		12	25 – 30	E		
Erastus Noyes		26	" "	E		
The Twins (fancy piece)			30 . 36	A B		
The Boquet "			23 . 34	F		
The Sisters "			23 – 30	G		
Albert Mosely			25 – 30	E		
Andrew Jackson	copy		" "	E		
Sir Walter Scott	"		" "	F		
Mr. —— Kazer his wife			" "	E		
Mrs —— Kazer his wife			" "	E		
John Stock, Jr. my Brother		13	21 . 26			
Young Artist	copy		31 . 36	H		
Marchioness	"		25 – 30	E		
Luther Stock my Brother		22	25 . 30			
Lucy Stock his wife		24	" "			
Thomas Warner, Jr.			" "	E		
Hosea T. Stock my brother		11	21 . 26			
Eliza J. Stock my sister		10	" "			
		Age	Inches			
Mary C. Stock do		8	" "			
Elisha Curtis, Jr.			25 . 30	E	[10]	
	John Curtis			25 . 30	E	

	\| Mrs. Curtis his wife			" "	E
	\| Binea Sperry, Brother in Law		25	" "	
	\| Mrs. Lavinia Sperry, my sister		20	" "	
	\| Maria L. Sperry, their child		1	" "	
	Gen. Andrew Jackson	copy		" "	E
	" Napoleon Bonaparte	"		" "	F
	John Stock my Father		46	" "	
	Patty Stock — my mother		42	" "	
	\| Lucius Stock — my brother		5		
	\| Edward D. Stock on one canvass		3	36 – 54	
	Miss Betsy T. Gould, my cousin		17	25 – 30	
	Miss Elizabeth Newbury			" "	E
1834	Mrs. Erastus Noyes my cousin		26	" "	E
	Erastus Bates			" "	E
	Charles Stocking		6	21 – 26	E
	Miss Irene Kennedy, from Hartford			25 – 30	E
	Charles Spencer		20	" "	D
	Chester Spencer		20	" "	D
	Emily Spencer		7	21 – 26	D
	B. R. Crane's Boy		2	30 – 36	F
	Miss Mary Pease			25 – 30	D
	" Eleanor Bordurtha			" "	E
	Mr. Colton			" "	E
	Hannah J. Shepard		3	30 – 42	G
[11]	Miss Mary Pease			25 – 30	E
	Mrs. Lavinia Sperry		21	" "	
	Maria L Sperry		2	30 . 36	
	Mrs. Martha Gould my Aunt			25 – 30	
	Mr. Hull, from Hartford, Ct.			" "	E
	Dr. A. J. Miller of Ludlow		84	" "	E
	do do		"	" "	
	Binia Sperry —		26	" "	
	Gen. Andrew Jackson	copy		" "	F
	Mrs. O. A. Seamans			" "	E
	Chester Harding, Artist —	copy		" "	
	Miss Caroline Ladd			" "	E
	My Dove, (fancy piece)	copy		20 – 24	

Lafayette	copy	25 . 30	F
Commenced 30 pieces of Anatomical			
Illustrations for Dr. Swan		25 – 30	G.E
Dr. James Swan		" "	
1835 Mrs. Albert Mosely		" "	E
H. H. Buckland		" "	E
Mrs. H. H. Buckland his wife		" "	F.
Mr. Ladd		" "	E
Mrs. Ladd his wife		" "	E
Miss Kent		" "	E
Lord Byron,	copy	12 – 15	D
Mrs. Mary Brunson — Russel, Ms.		25 . 30	E
Mrs. J. O. Moseley		" "	E

1835 Hopestill Bigelow		25 – 30	E	[12]
Mrs. " " , his wife		" "	E	
Frederick Merrick of Wilbraham		" "	E	
Miss Fidelia Griswold		" "	E	
Louis Collins		" "	E	
do do		12 . 15	E	
Henry Bailey from Georgia		25 . 30	E	
Mrs. his wife		" "	E	
Artemus Bigelow		" "	E	
Benjamin Fuller		" "	E	
Seth Hitchcock of Westfield		30 – 42	A.O.	
do do		" "		
100* A. Buck Lord		25 – 30	E	
Joseph Kneeland of Northampton		" "	E	
Lady Byron		12 – 15	D	
C. A. Bartlet's Child		30 – 42	G	
Cyrus Buckland		25 – 30	E	
Mrs. do — his wife		" "	E	
1836 Mrs. Mary Callander of Hartford		" "	E	
O. A. Seamans		" "	F	

* From time to time in the account-book part of the journal these marginal numerals appear. Each time Stock completed one hundred works, he would write the total in the margin of his journal.

Mr. Underwood now Dr. H. R. Vaille		" "	E
Geo. Richards		" "	E
Mrs. Eliza Tyler		" "	E
Elisha Tobey's Boy	3	30 – 42	G
Erastus Noyes	31	25 – 30	
Mrs. do his wife	28	" "	

[13] 1836 Thomas H. Stock my nephew 2 30 – 36

Roderick Merrick of Wilbraham		25 – 30	E

May 3d Went to Wilbraham in compliance with an invitation from the Teachers of Wesleyan Seminary. Took board and room with Mr. Titus Strong and stayed with him four weeks and painted

Rev David Patten, Principal, W. Sem		25 – 30	E
Wm. G. Mitchell, Teacher " "		" "	E
S. S. Stocking " " "		" "	E
John Roper " " "		" "	E
Miss —— Holland Preceptress "		" "	E
Rev. Reuben Ransom, Methodist		" "	E
Mrs. " " his wife		" "	F
John M. Merrick		" "	E
Mrs. " " " his wife		" "	E
Mrs. Martha Gale		" "	E
Miss A. Merrick		" "	E
Widow Lathrop		" "	E
Wm Brewer		" "	E
Mrs. his wife		" "	E
Stephen Utley		" "	E
Wm W. Merrick		" "	E

[14] Removed to John Carpenters to paint his
 family stayed two weeks and painted

John Carpenter		25 – 30	E
Mrs. Carpenter, his wife		" "	"
William Carpenter " son	20	" "	"
Candice Carpenter daughter	17	25 – 30	E
Hannah Carpenter "	9	" "	"
Francis Carpenter	7	" "	"
Miss Elvira Hancock		" "	"

Miss Sarena Hancock				" " "	
Removed to Mr. Abraham Avery: and					
stayed three weeks & painted					
Abraham Avery			25 – 30	E	
Mrs Avery	— his wife		" " "		
Mrs. J. Kellogg			" " "		
Mrs. Thompson			" " "		
Abel Bliss			" " "		
Mrs. Bliss	his wife		" " "		
Deacon Woodward		76	" " "		
Mrs. Woodward	his wife	73	" " "		
Wm S. Smith			" " "		
Mrs. Smith	his wife		" " "		
His two girls on one canvas			34 – 48	A.O.	
Returned to Springfield where I painted					
Henry Wilcox			25 – 30	E	
Benj Fuller			" "		
Hubbard Sampson's boy			30 – 38	H	

Aug 6 Went to Cabotville—a factory Village in Springfield. Took board [15]
and room of Mrs. Jesse Searl Stayed eight weeks and was well
patronized. Painted

Calvin Chase			25 – 30	H
Mrs. Chase	his wife		25 – 30	H
Stewart Chase	" son	9	22 – 26	E
Mary Chase	" daughter	7	" "	E
Lucius Harthon			25 – 30	H
Mrs. Harthon	his wife		" " "	
Edwin Harthon	" son	6	22 – 36	E
Elizabeth Harthon	" daughter	3	30 – 46	I
Chandler Holmes			25 – 30	A.O.
Miss Mary Collins			" "	H
" Ann Collins			" " "	
" Sophronia Crosby			" "	A.O.
John H. Dickinson			" "	F
Mrs. Dickinson	his wife		" "	F
Edward "	" son	3	30 – 40	"
Lyman Dickinson	"		25 – 30	"

Stephen Grover		21	" "	H
Albert Grover	his brother	14	22 . 26	F
—— Grover	" "	10	" "	"
Grover	" "	7	" "	"
Henry Atkins			" "	G
S. H. Brewer	not paid		" "	"

[16]	Miss Emiline Cady				
	" Eliza J. Leavett				
	Theodore Searl				
	Miss Mary Armes				
Oct 3	Returned to S. and painted				
	Artemas Bigelow			25 – 30	D
	H. L. Rogers			" "	A.O
	do	miniature		" "	E
	Binia Sperry	min—			
	Obed Look			25 – 30	H
	Mrs. Look	his wife		" "	H
1837	Two Anatomical Illustrations				
	for Wm G. Mitchell				H
	Franklin Burnet			25 – 30	"
	Mrs. Burnet	his wife		" "	"
	——	his daughter	2	30 – 36	I
	Miss E. L. Bunce of Hartford			25 – 30	A.O
	do	miniature			E
	Freeman Sears two children			36 – 48	A.H.
	Ephraim Williams			25 – 30	E
	Mrs. Williams	his wife		" "	E
	Col. D. P. King's boy			32 . 42	H
	Mrs. P. H. Sampson			25 – 30	E
	Ann Jennette Stock my sister		2		
	Eugene B. Sperry on one canvas		1	34 – 46	

[17]	The Young Widow	Fancy piece		22 – 26	A.O
	" Young Mother	" "		" – "	"
200	Eugene B. Sperry—nephew		1	25 . 30	
April 14	Went to Stafford Ct. . In consequence of the "hard times" did not				

receive so much patronage as I had expected. Boarded with Rev. J. H.
Willis — about two weeks and painted only those I had engaged, viz

Rev. John H. Willis	Universalist		25 – 30	H
Mrs.　　　　Willis	his wife		"　　"	
——	his son	2	30 – 42	I
Rev. Hollis Chaffee.	Universalist		25 – 30	A.O
do	miniature			

May 1st　Returning to Springfield, where I remained during the Summer,
doing but little painting　Having plenty leisure time I received a
course of lessons on the Piano forte from Miss Almira Davis
Painted

Gen An Jackson & Wife	copy		26 – 31	A.B
J. W. Stock ourself		22	25 – 30	
do			"　–　"	
John Stock, Jr.　my brother		17	22 . 26	
Eliza J. Stock　　"　sister		14	25 . 30	
Andrew Jackson	copy		"　　"	
John Gould from recollection		17	22 . 26	A.O
Martin Van Buren,	copy		25 – 30	H
Lord Byron Group three figures,	copy		"　　"	A.B
Rev. Mr. Kellogg from Sag Harbor. Meth			"　　"	F
Earle Woodworth's girl		5	34 – 48	A.B
Wm. Warner			25 – 30	A.O
Miss Almira Davis			25 – 30	
do　　do　Miniature				

[18]

Sept　Went to Wilbraham again in compliance with the requests of some
friends. Took board and room of John M. Merrick, than whom there
is not a more pleasant and generous man in the town. Stayed about six
weeks and painted viz.

Mrs. Gilbert of New Haven			25 . 30	H
Jane B. Stebbins		9	"　–　"	F
Miss Nash Preceptress W. Sem.			"　　"	G
Miss Sperry Teacher Piano Forte			"　–　"	"
Miss Loisa Badger			"　　"	"
Mr. Giddings, of Franklin Ct.			"　　"	F
Miss Giddings			"　　"	"
Miss Elizebeth Ford　Great Barrington			"　　"	G

	Jeremiah Moore. Oxford Ms		"	"	"
	Miss Mary Mudge Somers Ct.		"	"	"
	P. Cadwell		"	"	E
	Mrs. Cadwell his wife		"	"	"
[19]	Utley Cadwell, his son		25 – 30		E
	Elizabeth Cadwell " daughter		"	"	"
	Wm M. Merrick	4	34 – 48		H
Oct	Returned to S. and painted,				
	viz				
	Levi J. Holt		25 – 30		H
	Mrs. Holt his wife		"	"	"
	Miss Gear from Norwich. Ct.		25 – 30		F

Nov. Went to Westfield and not finding things as I had been led to expect stayed only one week and painted one portrait viz

	Mrs. Farnum	25 – 30		G
	Returned to S. and painted viz			
	Miss Hayward of Norwich Ct.	25 – 30		G
	Dr. Bassett's, daughter	30 – 42		A.B

Jan 1st 1838 Opened a room on Elm Street opposite Court Square and divided my time for six months betwene this and my room at my father's

Painted the following viz.

	Miss Mary Moore		25 . 30		
	Lester Belden		"	"	H
	Mrs. Belden his wife		"	"	H
	Ellen Belden " daughter	3	30 . 46		I
[20]	Miss Emily Griffin		25 – 30		A.O
	Miss Ann M. Haynes whole figure		42 – 60		B.E
	Wm Belden		25 . 30		H
	Mrs. Belden his wife		"	"	"
	Royal Belden		"	"	A.O
	Dennis Chapman		"	"	A.O
	Horace Beaman		"	"	H
	A. B. Crane		"	"	E
	Mrs. Crane his wife		"	"	"
	Harrison Bates		"	"	G

Mrs. Bates his wife		" " "	
Calvin Ward		25 – 30	H
Mrs Ward his wife		" " "	
Henry Ward " son	3	30 – 46	"
Miss Ward " Sister		25 – 30	"
B. F. Haskell		" " "	
Mrs. Haskell his wife		" " "	
A. Goodale of Amherst full size		42 . 66	B.O
P. L. Smith not paid		25 – 30	A.O
Wesly Noble		" "	E
Miss Maria Badger		" " "	
Luther Chapin		" " "	
Mrs. Chapin his wife		" " "	
Gilbert Chandler		" " "	
Rev. Wm. Livsey Methodist		" "	F
Nathanial Howard		" "	A.O

Cyrus Perkins half size				[21]
do miniature			E	
Mrs. Wm Livsey		25 – 30	F	
Jane Livsey, her daughter from corpse	5	34 – 48	A.O	
do		16 – 19	D	
Mr. S. Weeks of Marlboro Ms.		25 . 30	F	
Mrs. Weeks his wife		" "	"	
Edwin White		" "	E	
Lucy Huntly, colored person		" "	G	
Susan Gunn, daughter of				
Henry Gunn	7	36 – 52	A.O	
Wm Henry Collins ⎤ on one	5	"	A.F.	
Louis Edgar Collins ⎦	2			
John Bowles		25 . 30	G	
Mrs. Bowles his wife		" "	"	
James Russell, Jr.		" "	H	
Mrs. Russell his wife		" "	"	
Henry Russell " son from corpse	4	36 – 48	I	
Philo F. Wilcox		25 . 30	G	
Mrs. Wilcox his wife		" "	"	
Geo. Wilcox " son	10	" "	"	

Ellen Wilcox	" daughter	4	36 – 44	A.O
Francis Wilcox	" son from corpse	½	25 . 30	G
S. Stocking from Hartford Ct.			" "	A.O
Miss Mary Dimon			" "	E
Dr. J. Swan			27 . 33	
Mrs. Swan his wife			" "	

[22] Gave up my room in Street. Went to Wilbraham but being near the close of the term did not receive much patronage Boarded July with John M. Merrick about two weeks and painted as follows

Deland Merrick			25 . 30	E
Miss Flavia Brewer			" "	G
300 John Lathrop			" "	E
Repainted Widow Lathrop				B

Returned to S. where I remained a few days and painted S. Webster's

child from corpse		1	25 – 30	A.O
Homer Stock my nephew		1	" "	

Aug. 29 Opened a room in Cabotville with good prospects. Boarded myself my brother Lucius with me. Painted the following viz

Miss Harriet Sage		25 . 30	H
Richard Sage		" "	E
Irving Janes		" "	H
Mrs. Janes his wife		" "	"
—— " daughter		27 . 34	I
Mr. Winkly		25 . 30	H
Wm Porter		" "	"
Mr. Bacon		" "	"
N. S. Lawrence		" "	"

[23] John Dunwood		25 – 30	H
Henry Goodrich		" "	F
Miss J. Smith		" "	H
Miss Harriet Rice		" "	"
Frederick Adams		" "	

Sept. 22 Being obliged to give up my room returned to S. and painted

Joseph Russell	25 – 30	A.O

Oct. 10 Being disappointed in obtaining a room at Cabotville I went again to Wilbraham and painted

Harrison Morgan	25 – 30	G

A. L. Strong		"	"		
Mrs. J. M. Merrick		"	"	C	

Stayed about three weeks — boarded at J. M. Merrick's returned to S.

Nov Went to Cabotville where I remained till Christmas. boarded myself, painted viz

Clement Goodall of New Haven Ct.	27 . 34	A.O		
Mrs. Goodell his wife	"	"	"	
D. Marshall's child	"	"	"	
Miss Maria Rice Miniature			F	
" Sarah Ely do			"	
" Heziah Smith	"	"	H	
H. A. Hill. Barber not paid	"	"	"	

Horace Wilcox	25 – 30	H	[24]	
S. Churchill	"	"	"	
Mr. Gregory	"	"	"	
Warren Tobey not paid	"	"	A.O	
Miss Marietta Sage	"	"	G	
S. B. Lanckton	"	"	H	
Mrs. Lanckton his wife	"	"	"	
" " " daughter	2	30 . 36	I	
N. S. Tyler Dentist	25 – 30	A.O		
Mrs. Lucius Harthon	"	"	H	
Mr. Hazard	"	"	"	
Rufus Booth	25 – 30	H		
N. A. Harris	"	"	"	
Mrs. Harris. his wife	"	"	"	

Dec. 25 Returned to my father's to spend two or three weeks and then intended to return to C. to finish up work begun and engaged but as will be

Begun the following viz

Mr. Bly — Miniature		H	
R Norton do		E	
Mrs. Norton his wife do		"	
Alvin Hubbard	16	25 – 30	H
Olivia Hubbard	18	"	"
Epahrus Buckland		"	"
Mrs. Buckland his wife		"	"

[25] 1839 Jan 1st Was seriously burned as recorded in another place. I did not
paint for the first six months and but little during the whole year
Finished those commenced before my illness and painted the follow-
ing, viz

Mrs. Wm Moore		25 – 30	H
—— her daughter	2	30 . 42	I
Bridgeman Brewer of Wilbraham		25 – 30	A.O
Mrs. Richardson		" "	"

Sept Went to Cabotville to finish portraits commenced before my sickness.
Stayed about two weeks and painted

Moses Childs	25 . 30	A.O
Miss Sophia Smith	" "	"

Returned to my father's and painted

Geo. Richards	25 . 30	D
Mrs. Richards his wife	" "	A.O
Mrs. Luther Stock	" "	"
Wm Gunn	" "	A.O
Mrs. Isaac C. Stock	" "	

Painted Six full length Figures		
Anatomical Illustrations for Dr. Swan	36 . 72	F.E

1840 Feb. 19 Went to Cabotville, Occupied my former room, and boarded
myself. Sister Eliza with me stayed ten weeks and painted

	Canvas Inches		
[26] Cabotville, French Childs	25 – 30		H
Jam. Reed	" "		"
Geo. Dickinson	" "		"
Rev. A. A. Folsom Universalist	" "		"
Mrs. Folsom his wife	" "		"
Capt. Swasey	" "		"
Mrs. Swasey his wife	" "		"
O. H. Cooley	" "		"
Miss Sarah Hazen	" "		A.O
Mrs. Wyat	22 – 27		G
L. Jencks	25 – 30		H
A. Swasey	25 – 30		J
Mr. Gregory	" "		H

	Mrs. Phipps		" " "	
	Horace Adams		" "	A.O
	Mr. Winkley for altering		" "	D
	Mr. Wyat " "		22 – 27	B
May	Returned to S. and painted			
	Mrs. Benj. A. Bullard		25 – 30	A.O
	C. J. Upham's two daughters	6		
	Abby and Kate on one canvass	1	36 – 50	A.O
	Luther Stock	29	25 – 30	
	Thomas H. Stock, his son ⎤ on one	6		
	Wilbur Fisk Stock " ⎦	2	36 . 46	
	Omitted the following in my			
	account of work done in Street, 1838			

1838	Benj. Richardson		25 . 30	A.O	[27]
	Wm Moore		" "	H	
	David Smiths son		36 . 52	A.B	
	" " daughter		32 . 42	"	
	Eliza J. Stock miniature	17			

May 1840 Prepared to go to Westvill (New Haven Ct.) in compliance
with request of Mr. Clement Goodell and others. Left home Monday
May 25th rested at Farmington Ct. first night. Started again next
morning and arrived in Westville without place of our destination
about 3 oclock P.M. Distance from Springfield 65 miles. Took board
and room of Mrs. Fanny L Hotchkiss where I resided about five
months and painted as follows. viz

Enos Sperry	27 . 33	A.O
Mrs Sperry his wife	" "	"
Miss Harriet Sperry his daughter	25 – 30	"
Mrs. Hull do	25 – 30	A.O
E. H. Dickerman	" "	"
John H. Jacocks	" "	
Mrs. Clement Goodell	27 . 33	
Timothy Lovensboro of Bethany	" "	A.O
Mrs. Lovensboro his wife	" "	"
Capt Peck of Albany N. Y.	" "	"
Mrs. Peck his wife	" "	"

[28]	400	Geo. Baldwin's daughter from city	2	32 – 40	A.B.
		Wm. Baldwin's " " "	1½	" – "	"
		E. Perkins son " "	7	36 . 48	"
		L. L. Hotchkiss miniature			G
		Mrs. Osborn		27 – 33	A.O
		Mrs. Panton miniature			G
		John A Blake		25 . 30	A.O
		Mrs. Blake his wife		" "	"
		—— " son		32 . 42	A.B
		Chas. Kimberly		25 . 30	A.O
		Sidney Smith from city	5	36 – 48	A.E
		Chas. D. Gale		25 – 30	A.O
		James Codlington	6	36 – 50	A.E.
		Rev. Mr. Allen . from Albany — Pres		25 – 30	A.O
		Mrs. Allen his wife		" "	"
		Wm Ward		" "	"
		Eleazer Hotchkiss our host		27 . 33	A O
		Mrs. Fanny Hotchkiss his wife		" "	"
		Miss Betsey L. H. " daughter	19	25 . 30	
		Caroline A. H. " "	16	" "	"
		Martha F. H. " "	14	" "	"

Oct Took room and board at the Temperance House New Haven, kept by
H. P. Jones, stayed about four weeks and painted

		Rev. Mr. Merwin, Calvinistic		27 – 33	
		John Osborn		25 . 30	A.O

[29]		Mr. Bradley		25 . 30	"
		Wm A Law		" "	"

Stayed one week with, and painted

		John A. Pardee		27 . 33	"
		Mrs. Pardee his wife		" "	"
		John " son } on one	4		
		Albert " son }	1	36 . 48	B.O.
		J. W. Stock ourself	25	25 . 30	
		" " " miniature			

Dec 1st Returned to S. by Railroad to Hartford thence by private carriage
to my father's Painted as follows, viz

		Dr. J. Bassett		27 – 33	A O

Mrs. Bassett his wife		" " "	
Joseph Brown		25 – 30 "	
1841 Mrs. Brown his wife		" " "	
Willis Phelps		27 – 33 I	
Mrs. Phelps		" " "	
Phineas Tyler		" " A O	
Mrs. Tyler his wife		" "	

Feb. Went to Cabotville, my sister Mrs. Sperry kept house for me —
painted the following. viz

Miss Sarah Childs		25 . 30 H	
Mrs. S. Churchill		" " A.O	
Wm Porter miniature		" " G	
Wm Porter altering Portrait		" " C	

Cabotville Mr. H. Bennet		25 . 30 H	[30]
Mrs. Bennet his wife		" " "	
Mr. A. Frost		" " "	
Mrs. Frost his wife		" " "	
Miss Piper of Peperrell Ms		" " "	
" do do sister		" " "	
Miss Caroline Stock my sister	16	" "	
do			

Stayed five weeks and returned to my father's and painted the following viz

Mrs. Eunice Chapin of Cabotville — Ms.

Springfield Dennis Cook		27 . 33 H	
Mrs. Cook his wife		" " "	
Asa Wood		" " "	
Mrs. Wood his wife		" " "	
John Stock Jr. miniature	21		
L. Mc Quivey		G	
O. Stanley Curtis do	21	"	
O. H. Cooley do	20		
John Stock my father	54	25 . 30	
Patty Stock " mother	50	" – "	
Dr. J. M. Fletcher		" "	
Dr. J. Swan		27 . 33	
Miss Martha Swan		25 – 30	

Ann Jennette Stock	6	22 – 27	
Mrs. Lavinia Sperry	28	25 – 30	

[31] Mrs. Clark from Somers — 25 – 30 — A O

May 19th Went to Westville by private conveyance and to Hartford thence to New Haven by railroad Westville is a village within the limits of the township of New Haven and contains about 600 inhabitants. It is situated about two and half miles west of the city at the foot of a high rock — (West Rock famous in history as having been the secret residence of the Regicides of Charles, 1st King of England) Boarded again with Mrs. Fanny L Hotchkiss painted the following viz

Charles D. Gale miniature			G
Levi Baldwin do	65		"
Mrs. Roger's daughter from New Bedford	1½	30 – 40	A B
Mrs. Clarkes " " "	1½	" "	"
Hosea T. Stock	19	25 – 30	
Miss Smith from city	16	36 40	A E
Mrs. Austin "		25 . 30	A O
Wm A. Clark from Woodbridge		" "	"
Mrs. Clark his wife "		" "	"
Nelson Newton		" "	"
Mrs. Newton his wife "		" "	"
" daughter "	7	36 . 54	A E
H. D. Ward		25 – 30	A B

[32] Westville L. Loyde's daughter — 2 — 30 – 42 — A B

Edward Bray from Humphreyville	10	25 – 30	A O
Rev. J. E. Bray & Wife altering			F
A. B. L. Myer's son from Warren, R.I.	¾	" "	A B

Stayed fourteen weeks and returned to S. by same conveyance as before

Springfield painted the following viz.

Philos B. Tyler		27 – 31	A O
Mrs. Tyler his wife		" "	"
Lucius Tyler's daughter	2	30 – 42	A·B
3 miniatures of Mr Starkey copies			"
Miss Harriet Whitcomb of Randolph Ms	17	25 – 30	

Received a letter about this time from A. B. L. Myers flattering pros-
pects of business in his place of residence Warren R. I

Nov. 1st Set out by private conveyance, passed through N. Wilbraham,
Palmer, Brimfield, Sturbridge, Southbridge, to Thompson Ct, where
we rested the night. Next morning started proceeding through Goucesser-
ter, Chepachet, and Greenville villages. Providence, Barrington to
Warren, our place of destination, 81 miles Boarded with Mr. Myers
about eighteen weeks and painted the following viz.

	A. B. L. Myers			25 . 30	A.O	[33]
Warren	Mrs Myers his wife			" "	"	
	Charles Smith		21	" "	"	
	do miniature		"	" "	F	
	Wm Snell			" "	A O	
	Dr. Otis Bullock's daughter		4	36 – 48	A E	
	Saml F. Randall			27 – 33	A.O	
	Chas Collins			" "	"	
500	Esther Barney of Swanzy		17	25 – 30	"	
	Mrs. John D. Mason		39	" "	"	
	Joseph N. Simons		10	" "	"	
	Mrs. Maxwell		75	26 – 32	"	
	J. Driscoll	miniature			G	
	Wm Driscoll	do			"	
1842	John Hale	do			"	
	Wm Carr, 3rd	do	20		"	
	Horace Bean	do			"	
	Mrs Phebe Bosworth	do				
	Wm Martin			27 – 33	A O	
	F. A. Bliss of Rehobeth			" "	"	
	Wm Freeborn	miniature			G	

March Removed to John S. Monroe's where we spent 14 weeks
and painted the following viz

	Dr. Bullock of Rehobeth		73	27 – 33	A O	
	Amasa Mason	miniature			G	
Warren	Miss Frances Hoar min				G	[34]
	Wm Hathaway	do			"	
	Mrs Hale	do			"	

Miss. Elizabeth B. Childs do	14		"
John Andres, Spaniard do	14		"
Francisco " do	16		"
J. V. Tibbets do			"
Miss Sarah B. Hale do			E
John S. Monroe		27 – 33	A.O
Mrs. Monroe his wife ⎫ one canvass	1	" " "	
Emily daughter ⎭			
John A Monroe " son ⎫ 1	6		
Louisa S. Monroe " daughter ⎭ canvas	4		
Mrs. Wm. Martin ⎫ 1 canvas	3	36 . 40	A.H.
Julia her daughter ⎭			
Miss E. B. Child		27 – 33	
Theodore Warren from Fall River, Ms.			G
Edmund Cole miniature			
Benj. Norton of Swanzey		27.– 33	A O
Joseph Johns		" " "	"
Miss Mary Smith		"	"
J. W. Stock, ourself	27	25 . 30	
Mary C Stock , sister	17	" "	
The Morning Walk, Fancy piece		27 – 33	A O
My Dog "		30 . 40	F
George Washington . copy		25 . 30	F
[35] Warren The Young Widow . fancy picture		25 . 30	H
" Young Mother, " "		" _ "	"
My Dove		" _ "	F
Household Treasures "		" _ "	
Viaduct on Baltimore & Washington R. R.		27 – 33	F
Niagara Falls		" _ "	
Trenton Falls		" _ "	
Rufford Hall		25 – 30	
Ferry on the Derwent. Matlock Balt		" "	A O
The Millenium		30 – 40	
7 Illustrations of the Stomach for Dr. Swan		25 – 30	B.H

Received about this time good encouragement of business in Bristol
and accordingly removed June 17th. . Took board and room in Mrs.
N. W. Browning's Boarding House and painted the following viz.

Miss. Geraldine Browing	10	38 – 46	A E
Pardon C. Edwards miniature			I
Geo. M. Coit do			"
Allen Newman do			"
Capt. N. B. Heath do			"
" S. Pratt do			"
Miss N. B. Heath whole figure, min		12 · 15	B F.
Capt. G. Willard — cabinet size	60	9 – 11	A O
Mrs. Willard his wife do	57	" – "	"
H. Willard's son do	4	36 – 45	A E
4 Illustrations for Dr. Swan			A.F

Bristol Massadore T. Bennetts son	2	38 – 46	A E	[36]
Martin Bennets, son	4	38 – 48	"	
Capt J. L. Gardner's son	2½	36 . 45	"	
" Geo. P. Pearce		27 . 33	A.B	
" J. Darling		25 – 30	"	
Benj. Manchester		" "	"	
do miniature			F	
B. B. Covell from New Bedford min	29		I	
Capt. G. Willard min	60		H	
do "				
J. W. Stock min	27			
Mary C Stock min	17			
Viaduct on Baltimore & Washington R.R.		22 . 30	A O	
Columbia Bridge		" "	"	
Pirates Cave		25 . 30		

Stayed sixteen weeks and returned to Warren. Bristol is situated on
an Inlet from Naragansett Bay. 14 miles South of Providence and
contains about 4000 inhabitants. The principal business is mercantile
and it contains two large steam cotton factories. Business was very
dull during the time I spent in the place which together with the po-
litical troubles in the State, diverted the mind of the public from
patronizing the Fine Arts

Oct. 7 Warren Returned to Warren and took board and room at the "Com- [37]
mercial House." Capt. Luther Cole. Stayed about five weeks and
painted the following.

Luther Cole		25 – 30	A O
Mrs. Cole his wife		" _ "	"
Geo. Updike's son	4	38 – 48	A D
Miss Mary Tillinghast		27 – 33	I
Mrs. Stephen Mason		" "	A O
Miss Hannah Smith		25 – 30	"
Wm Collins. miniature			G
James Monroe "			G
Allen Cole "			"
Stephen Mason "			"
Hosea T. Stock "	21		
do do cabinet	"	8 – 10	
The Pets fancy picture		20 . 25	

Warren is situated on an Inlet from Narragansett Bay about 10 miles
South of Providence and contains about 2500 inhabitants. The people
are mostly engaged in the mercantile business and it is a very thriving
and entirprising town. Over 20 vessels engaged in the Whaling busi-
ness are owned in this town besides many smaller vessels employed
in the West India and Coasting trade.

[38] While in Warren I received a letter from B. B. Covell of New Bedford
giving me very good encouragement of business.

Nov. 14th Accordingly I left Warren the 14th of Nov and came to N. B.
and took board and room in Miss Albertson's Boarding House No. 45.
North Water Street and have commenced the following portraits and
miniatures viz—

Mrs. Pardon C. Edwards. min			A O
Capt. Charles Covell		27 – 33	
Mrs. Grace Covell his wife		" "	B.E
Mr. Wm Reed miniature			A O
Miss Hannah Baker		25 . 30	A B
J. F. Parsons miniature			A O
do "			C
Albert Lee Scranton	5	38 – 50	A E
Mrs. Wm. Bratel		27 – 33	"
Miss Sarah Kempton		25 – 30	A B
Mrs Thompson miniature			A O
600 Lucius Stock, cabinet size	15	8 – 10	

Rev. T. G Farnsworth, Universalist	27 . 33
Moonlight view on the Erie Canal	25 . 30
Black Mountain, Lake George	22 – 30
Caldwell Light House, Hudson River	" – "
Olympia copy	20 – 25 A.C.$\frac{A}{B}$

[1843] Saturday night Jan. 28th [39]

This week business has been very dull: another such week and I leave New Bedford. The only sitter I have had this week has been Mr. Farnsworth and my time has been occupied on his portrait and some landscapes which may by and by produce me something

Jan. 30th. This day completes 28 years of my life. It is a long period to contemplate, yet brief in remembrance are the evolutions of time. It seems but as yesterday when I was a boy and roamed the fields as free and gay as a lark or anything. Within that period is embraced much of suffering and affliction much of sorrow and pain, not unmingled however, with much of joy and happiness.

Feb. 4th I have painted nothing new this week but have been busy in finishing some paintings begun before. Business is very dull in this town this winter

Feb. 6th Yesterday (Sunday) was very stormy, it snowed all day and in the evening there was some rain. Today the sleighing is quite good and judging from merry jingle of the bells the people mean to improve it.

Saturday evening Feb. 11th [40]

I was called today to go to the house of a Mr. Woodhouse to paint a likeness from the corpse of his infant son aged 10 months. I took a sketch and shall finish it next week

Business looks more favorable than it did last week I have finished another miniature for B. B. Covell a copy of Pirate's Cave and another called the Pets. The weather has been very cold this week and the sleighing has been very good till last evening it moderated and rained in the night and all the forenoon which has destroyed the sleighing.

Feb. 18th, Have finished the portrait for Mr. Woodhouse with which he appeared well pleased Sent a box to Springfield on Thursday the

16th containing some paintings, Books, and other things Painted another Olympia. Drew my Lottery this evening I had seven Tickets left and drew back two of the prizes.

Business is so dull in this town and as there is no prospect of its improving immediately. I intend to leave the first of the ensuing week

[41] Feb. 20th. Commenced a miniature for H. Johnson Had packed up most of my things with the intention of leaving New Bedford for a while when being requested to paint this miniature concluded to remain one week longer

21st. Commenced a miniature for F. P. Bartlett also a landscape, been very busy to-day

22d Anniversary of Washington's Birth Day. The N.B. Guards turn out in honor of the occasion and take supper at the "Parker House" A very fine looking company. Had two sitters to-day J[ohnson]. & B[artlett]. and began another copy of Olympia

23d. Two sitters to-day the same as yesterday. Engaged 3 portraits to commence to-morrow. Business looks better now than it has done before since I have been in N. B.

Feb. 24th Commenced three Portraits to-day, viz
Mrs. S. B. Scranton, Widow Benj. Hill, and daughter Emily

Feb. 25th Mr. J. set to-day. also Mrs S[cranton]. and Mr B and began a cabinet size portrait of myself. This has been a busy week for me and most unexpectedly so, too.

Feb. 27th.. Snowed the first part of to-day and I have had only two sitters Mr. J. and Miss E[mily]. H[ill].

28th. Mrs. S. and Mrs. H. set today. Received a letter from Br. Hosea informing us of the death of

[42] Eugene B. Sperry who departed this life the 26th inst. at 10 minutes past 1 oclock. A.M. O. Eugene! Thou wast a brave little fellow and a generous' But thou art gone to thy happy home to join thy father ere thou knew ought of the cares and sorrows of this ephericral [sic] existence. He was 7 years old

March 1st. Miss Emily H. set in forenoon Mr. Johnson dissatisfied with his miniature and I shall paint another

March 2d. Had three sitters to-day, viz Mr. J. Mrs. S. and Mrs. H.

" 3d. Been a very cold blustering day. There was an alarm of fire

raised about 5.o'clock P.M. which proceeded from a small house on Elm Street; it was soon extinguished with little damage. Fires have been very frequent during the time I have been in this place but their Engine department is so efficiently organized and well drilled that they soon extinguished fires and comparitively small loss has been suffered in proportion to the number of fire Miss E. H. and Mr. J. were my only sitters to-day

4th Had two sitters to-day, Mrs. S. and Mrs. H. It has been a very cold day for the season. Business has been very good this week and I have the promise of several new jobs for next week.

March 6th My sitters today were Mr. J. Miss E. H. Miss Mary Shockly [43] and F.P.B[artlett]. The week commences with a bright promise of business and I receive encouragement from all quarters and I trust my efforts may be successful and give satisfaction to my success.

7th Mr. J. Miss M[ary]. S[hockley]. Mrs. H. and Mrs. Philips were my sitters this day. Received a paper from New Haven from which I learn the decease of Mr. Clement Goodell of Westville. He died on the 2d instant aged 64 years. In his death Westville has lost one of her best citizens, society and a large circle of relatives one, whose loss will not soon be made up to them It was through his means I was induced to go Westville and to his great exertions and influence I attribute most of my success. He was my firmest friend and most generous patron and it is with grateful feelings that I pay this tribute to his memory

8th Mr. J. Miss E. H. and Miss S. were my sitters to-day. Has been a very pleasant day.

9th I received only two sitters to-day viz Mrs. P. and Miss M. S.

11th. Yesterday and today was occupied on Mrs. P., and Miss M. S. portraits. I have finished up. Mrs. Scranton's, Mrs. Hill's, Miss E. Hill's Portraits, also the second miniature for Mr. Johnson and all give good satisfaction

March. 13th Today has been bad weather and in consequence I had only [44] one sitter Miss M. S. whose portrait I finished to-day.

14th Commenced a portrait for E. L. Foster to receive payment in carpenter work. Mrs. P. set today. Weather cold and blustering

15th — Received a letter from Caroline in New Haven containing news of
the birth of a son unto my sister Eliza wife of Charles H. Osborn
Born Feb. 26th. My sitters today were Mr. F[oster]. and Mrs. P.

Is it not a singular coincidence that at nearly the same moment that
while the child of one sister is receiving the breath of life, that of
another is struggling in the arms of Death and his gentle Spirit takes
its flight the one rejoices while the other mourns

Saturday Evening March 18th. — Business has not be so pressing this week
as the preceding. but as the general business of the town revives I
hope mine will improve. Mrs. P. and Mrs. F. called to-day

20th Finished Mr. Foster's portrait

23d Business this week so far has been rather dull. Finished Mr. Bartlets
miniature a very good likeness

March 25th I have finished up this week Miss Shockly's, Mr. Foster's
Portraits and a miniature for Mr. Bartlett. and nearly finished Mrs.
Philips portrait. Commenced another landscape and another Olympia.
I have been much engaged in preparing canvass this week. The gen-
eral business of the town has not been so dull in many years There
has been two or three arrivals this week of whaling vessels with good
cargoes

[45] March 28th. Commenced a miniature for Miss Emma Simmons to receive
pay of J. F. Parson's in trade It has been a very stormy day.

29th Miss. S. set today and Mr. Foster to make some alterations. The day
has been very pleasant and I have had many visitors.

30th Commenced a portrait for Mrs. Bassett Weather very fine

31st Mrs. B. and Miss S. were in to day.

April 1st To day has been very unpleasant and I have had no sitters. It
has rained all day and the wind from the N. E.

3d Mrs. B. had a sitting to day. Recd a letter from Hosea

4th Commenced a miniature of Capt. Chadwick

5th Rained all day and had but one sitter
viz Mrs. B. Sent a letter to Springfield also one to Providence to order
some gold cases.

[46] April 6. Fast Day, Capt C. was in also Mrs. Rogers with her little girl
to make some alterations on her portrait that I painted in New Haven.
Two ships arrived at this port today

7th. Had three sitters today viz. Mrs. B. Capt C. and Miss S. Received a
package of three plated miniature cases and return them by Hatch's
Express and enclose $15 to pay for 3 gold cases.

8th Capt C. Miss S. and Mr. J. set today

Sunday 9th. It is seventeen years today since I received the injury which
made me a cripple and the event is as fresh in my memory as yester-
day

Monday. 10th I had two sitters today viz. Capt. C. and Mrs. B. A meeting
for the choice of town officers was held today and the Whigs elected
thier whole board by a large majority the Loco's did not turn out in
thier whole strength. Sent a letter to O. H. Cooley in H. and a paper
to Miss A. E. Browning of B Received an order to copy a miniature
of Miss Cummings of Somerset deceased. to be left with H. P. Chase.

11th — Miss S. was all the sitter in today.

12th — Mrs. B. & Capt. C. set. — Received a package from Mr. Cutting
with 3 gold settings and 2 plated and Send him 2

plated in exchange and balance of $2.25 difference in price of plated [47]
settings It has been very pleasant weather for a week or more

13th No sitter today. Received a letter from Amana Mason

14th Only one Sitter this day, Miss E. S. Recieved a bundle by Railroad
from home. It has been very unpleasant weather today and has rained
some.

15th Mrs. B. Set this forenoon. Received a letter from Hosea. Finished
up Mrs. Philip's, and my portrait, Capt. Chadwick's. Miss Cum-
ming's miniatures all considered very good likenesses, also, finished
Olympia and two landscapes and nearly finished Miss Emma Sim-
mon's min. and Mrs. Bassetts Portrait I have not much work on
hand for the next week

April 20th It has been bad rainy weather for the last four days and my
business has been very dull I have had no Sitters this week and have
been engaged finishing up work on hand which is all completed and
I commenced another landscape today. tomorrow a new portrait.

21st Commenced a portrait (cabinet size.) of a Mrs. Fitch

22d Mrs. F. Set to day. It has been an exceedingly fine day almost like
summer An alarm of fire this evening from a candle shop soon out
not much damage

[48]　April 24th.　Only one sitter Mrs. F. Weather rather warm but cloudy. It rained like a flood yesterday afternoon and evening untill I went to sleep. I never heard it rain harder for so long a time. There was two arrivals on the 22d also two yesterday (sunday) of Whaling ships with full cargoes of oil

Received a letter from cousin Harriet all well　Another alarm of fire this evening at 11 o'clock　It proceeded from a large dwelling house on the opposite side of the river 2½ miles from here. which was entirely consumed

25th　Mrs. F. and Miss E. M. set to day

26th　Finished Mrs. Fitch portrait and sold a frame with it. it is pronounced a very good likness. Commenced a portrait for Mrs. Ward to receive pay in trade of her son J. Ward Draper & Tailor

27th　Commenced a Portrait of Joseph Ward to take pay from his shop Mrs. W. also, set today. Weather very unpleasant and rainy

28th　Mrs. W. Mr W. set today and begun a Miniature for Mr James Taylor of Dartmouth.

29th　Mr. W. and Mr. T. set today

[49]　May 1st　I have had two sitters today, Mr. W. & Mr. T. The forenoon was very unpleasant and wet. but it cleared up about noon and the after part of the day has been very pleasant

2nd　Mrs. W. and Mr. W. were in today. The weather very pleasant and the N. B. Guards gone on an excursion to attend the R. I. Election at Newport

3d　The Guards, returned this forenoon and were much displeased with their reception and entertainment in Newport. They describe it as being like an old fashioned "lection day noted for rum drinking. Gambling. etc. and said they had not seen so many men intoxicated for many a day."

4th.　I had three sitters today viz. Mr. W. and Mrs. W. and Stephen Jordan set for a miniature to take pay in trade

5th　Sent to Boston for Ivories recieved them this evening. Had four sitters today viz. Mr. J. Mr. W. Mrs. W. and Mr. T.

6th　Mr. J. set today　Business has not been very profitable this week. Only one cash job on hand. there is a prospect of business improving very soon,　Some jobs engaged for next week.

May 8 Had three sitters today viz Mr. J. Mr. W. and Mr. T. There was a [50]
most beautiful May-Basket, hung for me this evening and the contents
unlike most are very valuable. The hanging of them is very fashion-
able in this town more so than in any place where I have resided. Sent
a letter to Springfield today

9th Mr. J. set and commenced a miniature for Mrs. J. Rogers. Received
a letter from O. H. Cooley all well

10th Mr. J. and Mrs. R. and Miss E. S. very pleasant weather for a few
days.

11th Mr. J. & Mrs. R. and Mr. W. were my sitters to day it has been an
unpleasant and wet day. Been packing a box this evening to send to
my friends in Springfield

12th Mrs. R. set this morning and I commenced a Portrait of Mrs. H. A.
Sparrow, sent the box directed to Brother Isaac. Boston.

13th Mrs. R. and Mrs. S. were in today.

15th Only two Sitters today Mrs. R. and begun a portrait for Caroline Fes-
senden to receive pay of Mr. Ward.

16th Mrs. S. Set today Received a letter from home all well box ar-
rived safe Caroline at home wants me to go

17th Only one Sitter to day Mrs. S. [51]

18th Begun a Miniature for a Mr Bessey of Wareham to be finished on
saturday and consequently had to take two sittings to day.
Sent a letter to Eliza. Business continues to hang off people I find
will take thier own Time for these things

19th Two sitters today Mr. B. and Mrs. S.

20th Finished Mr. Besse's miniature and gave very good satisfaction

22d Miss F. sit before breakfast and Mrs. S in the forenoon.
Not much business in prospect for this week.

25th Not doing much in the way of my business this week. Received a
bundle and letter from home today

30th Been engaged finishing up old jobs untill today begun on two new
ones, viz. one job for Willard Sears, of 5 portraits—his children—
begun the boy about five years old full statue. Begun a portrait for
a Mr. Russell and am to paint his wife.

31st Commenced a Portrait for Mr. Bursley. and recieved a sitting from
Mr. R. and Mr. S. boy

June 1st Mr. B. Mr. R. sit today and commenced 2 portraits of Mr. Sears girls. Sent by Hatch's Express to Providence for 3 gold miniature settings sent one back in exchange and enclosed the balance $10.50

[52] June 2d. Mr. B. and Mr. S. boy, were my sitters today and I also began another portrait of another of Mr. Sears girls.
 The weather has been very cold for two or three days almost like fall weather

June 3d Only one Sitter today, viz Mr. R. finished up all old jobs and probably shall be very busy for two weeks to come on new jobs

June 5th Had four sitters viz. Mr. B. Mr. R and two of Mr. S. girls. The weather very fine and warm. Business appears to be reviving in this town Sperm oil has been rising for a few days past and is now over 60 cts per gallon and the prospect is now it will continue to rise which will make times quite brisk again. Sent a letter to Springfield received a package from Providence of 3 min. settings and 1 bl. of Gum Mastic

6th Four sitters today, Mr. B. Mr. R. and two of Mr. S. children

7th. Mr. B. and two of Mr. Sears girls and commenced a portrait of his oldest daughter

8th Three of Mr. S. children and begun a portrait of a Mr. Smith

[53] June 10th Three sitters today viz. Mr. Smith and two of Mr. Sear's daughters. Business has been very good this week, and no doubt will be next week. Received a letter from Hosea from home.

12th Mr. S. and three of Mr. Sears children sit today, and I begun a portrait of Mr. Russell's wife which has kept me very busy all day Weather warm and pleasant

13th Four sitters viz two of Mr. S. children Mrs. R. and Mr. Smith

14th — Two of Mr. S. children and Mrs. R. Sit.

17th Saturday evening. Have completed Mr. & Mrs. Russell's Portraits Mr. Frederick Smith's, Mr. Bursley's and most of Mr. Sears family portraits, I shall finish them up next week and expect two or three new Sitters. Today is the anniversary of the Battle of Bunker Hill and most of the people have gone to Boston to attend the celebration Weather very pleasant

20th Commenced a portrait of J. R. Paul also one of Mrs. Sears

July 1st Finished up Mr. Pauls and Mrs. Sear's portraits and all others
on hand. The weather has been very warm for the last ten days

July 3d Great fire in Fall River yesterday, begun about 3 o'clock P.M. and
was not checked till this morning.

About 200 houses are said to be de- [54]
stroyed and the loss is estimated at half a million of dollars

July 6th Begun a portrait of Mr. Sears.
" 8th Have received three Sittings from Mr. Sears this week —
" 10th. Mr. Sears sat and commenced a Portrait of Capt. Shockley.

13th Commenced a Portrait of a Mr. Willcox and also, of a Miss Willcox,
Mr. S. and Capt. S. set today

20th Commenced Mrs. Thomas Ricketsen and Son 2 years old both on one
canvass

21st Sent a letter to father in Springfield enclosing $10.

22d Finished up Mr. Sear's, Mr. Wilcox, and Capt Shockleys Portraits.

27th Begun a Miniature of Mr. Woodhouse also a full length Portrait of
a son of Mr. Thomas Fuller a sailor now at sea

29th Begun a Miniature of Mr. Uriel Snow from Dartmouth Finished
up this week Miss Wilcox, and Mrs. Ricketsen's & Son's Portraits

Aug 14h Finished up all the work on hand and leave this town tomorrow [55]
by private conveyance for East Randolph, to pay a long contemplated
visit to my Uncle Whitcomb

I have been as liberally patronized in this town, as could be ex-
pected. Considering the great depression of business the last three
months I have had as much work as I could conveniently attend to
and were I disposed to stay no doubt there would be enought to keep
me untill winter. So far as I am able to judge my work has given good
satisfaction and if disposed to return next Spring I am assured that I
can recommence business with better prospects as it is expected there
will be a greater demand for Sperm Oil and therefore money will be
more plenty, and business more lively.

I have painted to order 37 Portraits and 18 miniatures, besides
several landscapes etc.

I shall write [crossed through] recapitulate the whole number with
their names on the accompanying pages for the greater convenience
of reference

Boarded in the same house all of the time I spent in this place and am well satisfied with the treatment received

[56]

		yrs	Size of canvas	
New Bedford	Portraits Painted			
1842 & 3	Capt Chas. Covell		27 – 33	
	Mrs. Grace Covell		" "	B E
	Miss Hannah Baker		25 – 30	A B
	" Sarah Kempton		" – "	"
	Albert Lee Scranton	4	38 – 50	A E
	Mrs. Wm Beatel		27 – 33	"
	Rev. T.J. Farnsworth Universalist		" – "	
	Mr. Woodhouse' infant boy	1	25 – 30	A B
	Mrs. S. B. Scranton		25 – 30	
	Mrs. Binj. Hill		27 – 32	
	Miss Emily Hill		27 – 32	B E
	Miss Mary F. Shockley of Middleborough		25 – 30	A O
600	Mrs. Wm Philips		" "	"
	Mr. E. L. Foster		" "	"
	Mrs. Rhoda Bassett		25 – 30	A.B.
	Mrs. Fitch cabinet size		8 – 10	A.C.
	Mrs. Jonathan Ward		25 – 30	A B
	Mr. Joseph Ward		" – "	"
	Mrs. H. A. Sparrow		" "	"
	Miss Caroline Fessenden		" – "	"
	Mr. James Russell		27 – 33	
	Mrs. Harriet Russell		" – "	B E
	Mr. Enoch P. Bursley		25 – 30	A.C.
	Mr. Willard Sears		" "	A.B.
	Mrs. —— Sears		" "	"
[57]	Miss Hannah G. Sears	17	25 – 30	
	" Ruth B. Sears	12	" – "	
	" Mary Sears	10	" – "	
	" Elizabeth Sears	8	" – "	
	Willard T. Sears	6	40 – 50	E.E.
	Mr. Frederick Smith		27 – 33	A.B.

" James T. Paul		" "	A E
Capt H. Shockley		25 – 30	A A
Rodolphus Wilcox		" "	A E
Miss Maria Wilcox		27 – 33	A E
Mrs. Thomas Ricketson and Son		36 – 42	B.E
Thomas A. Fuller	2½	38 – 46	B.E
Lucias Stock (cabinet size)		8 – 10	
J W Stock do		" – "	
Olympia a copy		19 – 25	A D
do — do —		17½ – 22	A B
do — do —		" – " "	

Landscapes

Pirate's Cave	22 – 30
View on the Erie Canal	" – "
Caldwell Light House	" – "
Black Mountain	" – "
The Playful Pet	18 – 22
Pirate's Cave	22 – 30
Viaduct on Baltimore & Washton R.R	" – " G
View in the Schuylkill River	" "
Soaking Mountain, on the Mississippi	22.– 33

New Bedford Miniatures

Mrs. Pardon C. Edwards, morocco setting		A O	[58]
Mr. William Reed	gold setting	A.J.	
I. F. Parsons	do	"	
do	morocco "	C	
Mrs. Thompson	gold setting	A.G.	
B. B. Covell	do	G	
H. Johnson	Plating setting	A D	
" "	morocco	C	
F. P. Bartlett		F	
Miss Emma Simmons	Plated Setting	A.F.	
do	do		
Miss Cummings a copy	morocco "	G	
Capt D Chadwick	gold setting	A G	
Mr James Taylor	do do	"	

S. D. Jordon	morocco	A.O.
Mrs. James F. Rogers	Plated "	A.B.
Mr. Besse	gold	A.G.
Mr. Wm Woodhouse	do	"
Mr. Urial Snow	do do	"
J. W. Stock		

New Bedford is a large and flourishing sea-port town situated on Buzzard's Bay about 60 miles S. West of Boston, with which city it is connected by Rail road also with

[59] Providence. It has a population at this time of rising 12,000 inhabitants mostly Supported by the Whale fishing. Between 200 and 300 ships are owned in this town employed in Whaling besides many smaller craft engaged in the coasting trade

Aug. 15th Hired a horse of H. A. Sparrow, and proceeded to E. Randolph Mr. Bartlett came with me to take back the horse. Had a very pleasant ride distance about 40 miles. Found my Uncle's family all well and glad to see me. Spent 1 month with them very pleasantly and painted 5 portraits and 1 miniature, viz, E. Randolph

1843	David Whitcomb	my Uncle	60	27 – 33	
	Abigail Whitcomb	" Aunt	57	" – "	
	Harriet Whitcomb	" Cousin	18	25 – 30	
	Henry D. Whitcomb	"	6	40 – 50	G
	Elisha Wales	"	3	38 – 46	
	Mrs. Whitcomb	miniature Gold setting			A.D.
Landscape	Sunset in New Jersey			22 – 30	

Sept 13th. Left My Uncles about 8 o'clock AM and drove to Boston where we (Lucius, Cousin John & myself) arrived a few minutes past 12. We Met Br. Isaac C. at the Depot who had arranged for our conveyance to Springfield They immediately put the carriage and myself on a platform car and left B. with the Norwich Steamboat train at 1 o'clock and arrived at Worcester about 3 o'clock where I awaited the arrival of the regular evening passenger train for S. Left Worcester about 6 o'clock arrived in S and was at home at about 9 o'clock. Found my friends all well and glad to see me having been absent nearly 2 years. During this time some changes had occurred in the family, viz, Brother Luther died Jan. 27, 1842 and my brother John left this country for France in Jan of 1843. and father lost his situa-

tion in the Armory and turned his attention to farming I remained at my father's house until the last of Dec; when took a room in Street

painted at	E. D. Stocking	25 – 30	A.O	[60]
home	Frances Ann his daughter	36. 4.	A.E.	
	James Swan	25 – 30		
	Isaac C. Stock	" "		
	Mrs. P. H. Grover	" "	A O	
	" Mary A Hawks	" "		
	William Gay deceased	40 – 50	A.E	
	duplicate	21 – 26	E.	
	Mr. Lehmans child dead			
	A. J. Stock — sister	30 – 36		

Removed to my room over the Post Office and painted			[61]
Rev. D. J. Mandell	25 + 30		
E. A. Clary	27 + 33	A.B.	
James Willis	25 + 30	G	
wife	" + "	"	
son	" + "	"	
do	" + "	"	
do deceased	32 + 40	A.B	
J. W. Gorham's boy deceased	25 + 30	A B	
S. E. Bemis " "	" + "	"	
Lewis Blake	" + "	A O	
E. M. Holcomb	" + "	H.	
L. J. Holt's boy deceased	28 – 30	A.E.	
do	" "		
Mr. Lehman	30 – 38	A.E	
Mrs. L—— & child	" + "	"	
Almira Davis —	25 + 30	H	
J. W. Stock	" + "		
The Pets	30 – 36		
The Pupils	" + "		
View on the Hudson	22 + 30	H	
Sunset in New Jersey	24 + 11		
A. Russell miniature		E	

[62] 1844 May 1st. Formed a connection with O. H. Cooley in the Daguerre-
otype business and removed to Fountain Row. and painted

Thomas Moore		25 + 30	A.O.	
Ripley Swift		" + "	H.	
J. Ingraham Jr.		" + "	A.O.	
Mrs. Penfield		" + "	"	
F. Gouch		" + "	"	
Miss Mc'Clintock		" + "	"	
Mrs. L. Blake		" + "	"	
L. Bartlett		" + "	"	
J. T. Rockwood		30 . 56	"	
Chas. H. Osborn		25 " 30	"	
E. J. Osborn	wife	" + "		
Joel Osborn	son	32 + 40		
S. Crane	min		H	
Eugene Judd, Southampton		25 + 30	A B	

700 appears to the left of J. Ingraham Jr.

Aug. 20. Removed to Westfield and took a room over the Bank where I
painted

Jasper R. Rand		25 + 30	G
Mrs. Rand	wife	" + "	"
George	son	" + "	"
Albert	do	" + "	"
Lucy	daughter	" + "	"

[63]

Ellen A. Rand	daughter	25 − 30	G
Jasper R "	son	38 − 46	A.B.
Addison	son	" + "	"
Charles Monroe		25 + 30	H
Mrs. "	wife	" + "	"
Jasper H. "	son	36 . 48	A.B.
Mrs. Marble	Sister	25 + 30	H.
D. M. Goff		21 + "	"
Mrs. Margaret	wife	" + "	"
James Whipple		" + "	"
Mrs. Mary "	wife	" + "	"
Porter	son	38 . 46	A.B.
Joseph Arnold		25 + 30	A.O
Mrs. Caroline "	wife	" + "	"

Orville Root	" + "	H
Mrs. Harriet " wife	" + "	"
David Brown	" + "	"
Mrs. Julia wife	" + "	"
George Howe & sister		
Mary Adela — in group	38+46	B.E.
Wm. Boyle	25+30	A O
H. W. Monroe	" + "	H
Mrs. Margaret A. wife and		
Mary. daughter in group	36+42	B O
Addison Gage	25+30	H
Mrs. " wife	" + "	"

Westfield John Loomis	25+30	H	[64]
Mrs wife	" + "	"	
Harriet Brown	" + "	A.O.	
Maria Root	" + "	H	
Gen Washington on Engine		"	
Henrietta Russell corpse from S	36+48	A.F.	
Wm K. Plummer . Pupil for			
Three months $50		E.O.	

Dec. 7th. Came to Springfield to settle up accounts with Mr. Cooley and to dissolve partnership previous to his going South. Returned to West-field in about one week and took a larger room over Cook's Jewelry Store Jessup's building and painted

Oliver White	8+10	H
Ruth Coles	25+30	"
Nancy Coles	" + "	"
Milo Drake	" + "	"
Orville Root	" + "	"
Mrs. Harriet wife	" + "	
Harriet Lamberton	" + "	"
Andrew Campbell	" + "	A.O
Hiram Harrison	" + "	G
Mrs wife	" + "	"
Julietta daughter	" + "	"
Martha Ann "	" + "	"
Izetta "	40+50	A.B

[65] 1845 H. W. Monroe 8 + 10
 Lucius Stock " + 10
 Feb. 15th Removed to Springfield to my father's house and painted
 Francis & Mary Wilcox in group
 deceased children of P. F. Wilcox 40 + 50 B.E
 Francis Wilcox duplicate 21 + 26 E
 Mary " do " + " "
 Finished up Henrietta Russell
 Painted Sign for Myself
 April 7th Removed to Cabotville to fulfil some engagements made by Mr.
 Cooley and painted
 Josiah Stevens 25 + 30 H
 Mrs wife " + " "
 Mrs. B. R. Stevens " + " "
 Jane do daughter " + " "
 Franklin son " + " "
 Albert son 32 + 40 A.O
 Maria Sage 22 + 26
 May 7th Returned to father's and took a pupil Miss Abby Wellman 3
 months for $50 painted
 Two full size Skeletons for Dr. Swan B.O
 2 Transparent window shades

[66] 1845 Mrs. Ladoc Dimon 25 + 30 A O
 Antoinette Seamans " + " H
 Augusta " 30 + 36 A.O.
 Frances " 40 + 50 A.B
 Miss Catherine Morgan Somers,
 deceased 25 + 30 A E.
 N. Nelson miniature H
 Dr. Richards for altering C
 The Sisters 22 + 26
 The Novice " + "
 The Spanish Boy " + "
 The Indian Maid 13 + 16
 The Watcher 12 + 14 A.O.
 Indian Scene Landscape 22 + 30 A.O.
 The Log Cabin 20 + 27 G

Mr. Cooley haveing returned from the South formed another partner-
ship in business and fitted up a Portrait + Daguerrian Gallery in
Lombard's Block, opposite Chicopee Bank Main St.

Aug 11th Moved into our rooms and painted

Ellen Rollins	32+40	A.A.	
J. Holdredge	25+30	H	
Mrs. do wife	" "		
S. M. Heywood	" + "	A O	
Mrs. Ferrar's girl Cabotville	30+36	A.E	[67]
Mr. Wilson Eddy	25+30	H	
Mrs. " wife	" + "	"	
Helen daughter	38+46	A.E.	
E. Harris daughter	40+50	"	
Joel Chapin's boy	25+30	A.B	
800 E. T. Amadon do deceased	" + "	"	
Mrs. J. Caldwell	" + "	A.O	
Jason Bailey	25+30		
Mrs wife	" + "	J	
John Hayes	" + "		
Miss Sarah Wood	" + "		
Austin Stewart	" + "	A.O.	
Mrs. O. H. Cooley & babe group	" + "		
Lavinia Sperry miniature			
Fancy piece do			
Norman Marsh do		H	
Rufus Elmer's boy do — dead		H	
John & Louisa Stock in group	40+50		

Received an invitation to revisit New Bedford with good encourage-
ment of business. Concluded to go and started with brother Edward
Dec. 9. and went through in one day by Railroad Stayed with Wil-
lard Sears the first night and next day moved into my rooms at No.
30. Purchase St. and board ourselves —

New Bedford Barker Cushman	25+30	A.O.	[68]
Dec 9th Obed Cushman	" + "	"	
Ichabod Clapp	" + "	"	
Rebecca Mathas	" + "	A.B.	

Henry Grey		" + "	"
Sarah Howland		" + "	"
duplicate		" + "	C
Dr Ward Dentist —		27+33	A.E.
Mrs. wife		" + "	"
Thomas Ricketson		30+36	B.D
Altering Group of Wife & Child			E.
Capt. Fred. Cushman		" + "	B.D.
Mrs. wife & daughter group		39+43	C.O
Capt. Clement Covell		27+33	A.E.
Clara Wilson		31+39	B.O.
Henry Pierce		25+30	A.B.
Mrs. " wife		" "	"
Wm Ashley Fall River		" + "	"
Sam. Dennis Springfield		" + "	"
Mrs. Lucy wife		" + "	"
Mr. Benj. Sweet Fall. River		" + "	"
Mrs. wife		" + "	"
John Chapman		" + "	"
Jona. Ward		" + "	"
Capt Swain Dartmouth		" + "	A.E.
Mrs. " wife "			"

[69]	1846 El. Foster		25+30	E
	Col. Hatch		" + "	
	Mr. Wood		8+10	E
	Altering J. Wards portrait			C
	Scene on Ohio River Landscape		20+28	

Feb. 15 Returned to Springfield to finish up some engagements and painted.

C. H. Payne		25+30	A O
Jason Hubbard		" + "	A.E.
Charles Child's daughter Mary		36+46	A.H.
Ephraim Harris		25+30	H.
Mrs. " wife		" + "	"
Larkin	son	" + "	"
Helen	daughter	" + "	"
Ephraetta	do.	32+40	A.E.

Mrs. Robinson's girl deceased	27 + 33	"
George Perry Pittsfield	25 + 30	A O
Mrs. wife "	" "	"
Mrs. Tom Moore	" + "	"
Emeline Field deceased	" + "	"
Mrs. Hancock and baby deceased in group	" + "	B.O
Mrs. Wm. S. Marsh, dead	" + "	A.O.

Having now decided to go back to New Bedford and Mr. Cooley wishing to [70]
remain in Springfield we concluded it best to dissolve copartnership
in business and accordingly the dissolution took place on the 20th
March, 1846. I stayed to finish up old engagement, and did not leave
for New Bedford untill the 3d of April. I was also detained, for a few
days by some business with Sister Lucy who was in the last stage of
the Consumption. Bought a tract of land of her gave $600. and
bound myself to bring up and take care of her oldest son, Thomas
Henry untill he shall be of lawful age and then to render account to
him or his heirs of what property was conveyed to me. Mrs. Noyes
took the same bonds for her other son Wilbur Fisk I hope our lives
may be spared to fulfil the trust in such a manner that they may be an
honor to ourselves and become useful and respectable men

April 3d I left Springfield at 7 o clock A. M and arrived in New Bedford
the same evening I found that during my short absence business of
all kinds had become very much depressed caused partly by the un-
settled state of our foreign relations and also by the great scarcity of
money.

The shipping lying idle at the wharves the owners being fearful of a war [71]
with England about Oregon and not wishing to fit out untill that ques-
tion was decided All these things had a tendency to affect my busi-
ness and I was disappointed of many jobs which were engaged before
leaving in February. However I recommenced painting and executed
the following viz

Mrs. Foster	25 + 30	A.O
Isaiah Foster	" + "	"
Rhody Sherman	" + "	"

T. W. Sears —		" + "	"
Mary Sears —		" + "	"
Mrs. Hannah Hamblin		" + "	"
Mrs. Betsy Thatcher		" + "	"
Col A. D. Hatch		22 + 27	"
Cynthia Ward		25 + 30	A.D.
Wm Ward —		30 + 36	B.E
Mrs. Clement Covell		27 + 33	A.E.
Mrs. Dennis		25 + 30	A B.
Foster S. Dennis		" + "	"
H. Soule		" + "	"
Mrs. Sarah wife		" + "	"
Mrs. Sam'l C Ward deceased		" + "	"
[72] Mrs. Jacob Brown		27 + 33	A E
S. W. Crosby Edgartown		25 + 30	A.H.
John Childs		" + "	"
Mrs. Harriet Faber		" + "	A.B.
Ebenezer Hallet Yarmouth		" + "	"
Theodore Besse		32 + 40	A.E.
Mr. Cyrus Whelden Turkapaw, La. miniature			A.O
Alterations in S Ward's portrait			C
do Mrs. Cook's			B
do E Dennis			C
J. W Stock		22 + 26	
Indian		13 + 16	
Fancy piece		12 + 14	
do		12 + 15	
1 Landscape Passamaquoddy Bay		20 + 28	A.E.
1 do White Mountains		18 + 24	
1 do View in Palestine		" + "	
1 do Saltwood Castle		15 + 24	
" do Baths at Gravesend		" + "	

July 28th Having finished up all the work on hand left New Bedford at 7
o clock A. M and arrived in Springfield same evening. Found my
sister Eliza at home and had the pleasure of visiting with her for a
few days. Sister Lucy died the day after my arrival (the 29th) and
I attended the funeral with the rest on the 31st.

She lived much longer that than we thought it possible when I left in April [73]
 and suffered a great deal before her spirit was released and at rest.

 Eliza returned to New Haven the 1st of Aug. having been at fa-
 ther's for five weeks.

Aug. 4th Removed to the Street into the room with Mr. Cooley which
 I formerly occupied and painted

	Charles Childs	25 + 30	Λ O
	Mrs. " wife	" + "	"
	Mrs. Joshua " mother	" "	"
	Susan daughter	38 + 46	A
	Rev. H. W Lee — Episcopal	30 + 36	
900	Mrs. Huntington copy	22 + 27	
	J. Stebbins Esq.	25 + 30	A.O
	Joseph Flynn	" + "	"
	Robinson	" + "	
	O. H. Cooley	" + "	
	Thankful Ann Glinn	" + "	H
	Edmund Day Fredonia N. Y.	" + "	A O
	Mrs. " "	" + "	" "
	John Phelps	36 + 42	A.E.
	Albert Holcomb	34 + 41	A.H.
	Mrs. N. P. Curtis Boston	22 + 27	H.
	Maria Sperry min		
	Altering E. Curtis Jr.		C
	Blakes		A.

THE SINGLE EXTANT LETTER OF
JOSEPH WHITING STOCK

When hear from you will write again. I wish had some of your apples not one to be had here, been without nearly 3 weeks I wonder if they would freeze coming from Springfield. We are having a thaw here.

Port Jervis Jan 7, 1855

Br Otis

I have been so very busy since your letter was received that have not found time to write you sooner. Yours from New Haven was received and I got together all the Tickets that were at hand and sent to Isaac which amounted to 28 and have not heard as yet if he sold them although presume he did. I was all sold out two or three days before the Drawing but Tickets were returned from Middletown, Goshen and by Jenkins which I again sold out here, untill Saturday night was all sold out here and supposed all sold everywhere as gave positive orders to have every ticket unsold returned on Saturday. On Monday there was quite a call for them — but when the mail came in at noon there was over 40 tickets returned which I sold part and the remainder were raffled off before the Drawing so I had not one Ticket left. So you see after your letter was received and I had sent to Isaac there was no time untill Monday that I had any tickets to spare to send to you, but you are better off as should be likely to send a blank. There was a large gathering at the Drawing which was in the Hall over my room. It commenced about 8 o'clock and lasted nearly 2 hours. Among the 86 tickets sent to New Haven there are 8 Prises. The Portrait of Calhoun $30– One Landscape $35. I, do 30– shell frame $25. Shell Box $8.00, do $6.00. Large Engraving. $5.00, Crayon Pce $4.00. They do better this year than last as they are more valuable prises. I have not received Isaac's list of names so do not know who drew them. I sent 8 tickets to Hosea and one of them drew a small shell Box valued at $6.00. Hosea sold or gave away all but two of these Ed has 2 of them, I dont know whose ticket drew it. Four Prises were drawn in Middletown Mrs. Tom Harding drew the Clock. Betsey didn't have a prize this time although they had 5 or 6 tickets. The rest of the valuable prises were drawn in this place and everything went off pleasantly. I succeeded with it much better than I expected. If money had been easy could have sold 1000 tickets easier than did these. The his folks [sic] were all well as usual also

Ed & Elicta I have been thinking strongly of altering the house to make 4 tenements 2 up stairs and two down stairs. I will raise the back part where father lives and made an entrance under the stoop where the Hatchway now is. which can be put on the backside. The front Tenement can be made into 2 Tenements very easily at little expense. I will put pumps into the chambers and make convenient so think might rent the 4 tenements for $300 which would pay good interest. Who do you think would be the best joiner to do the job. It ought to be done before renting time if at all, and probably it could be done as cheap now as ever. Write who you think would do it best and quickest. My plan is to give each lower Tenement 2 bedrooms each one where they now are and then take the room occupied by the back stairway, pantry and bedroom make it into 2 bedrooms of equal size and let the front tenement have an entrance into our front hall where the closet is, and into other bedrooms by either cellar or pantry door. Shutting up one door. I wish you would give me the length of the bedroom, pantry & cellarway that I may know size of bedrooms. I have not time to write more now will write to mother soon. Give my love to all. My health is good, also Toms. write soon, &c J.W. Stock

Erie R.Road had not paid their men for nearly 3 months until Friday before the Drawing they paid off one month's wages. Which was just in time for my business. I want to hear from Isaac and if he sold all out I shall be satisfied.
It has started up some new customers since buying out Corwin. I have engaged over $120 in portraits for some of the best families in the place So I think it will had in others. Mr. Farnum & wife, the one that own the place with the Fountain which you will recollect of passing in coming to my room will have their portraits painted and should not be surprised if had work enough to last until Spring. I gave notice, should leave 1st of Feb but hope will keep me busy until 1st of April as I dislike to move in the winter. If I stay untill that time and Money gets easier I will have another small Drawing and sell all the tickets here. The New Haven people may be disappointed if do not leave here before the 1st of April but can not help it shall go there when I make a move
Hosea wrote to me that Mary has a long time getting home, the trains did not connect and she did not get home until Sunday night. Did you use those notes I sent for Holmes, Booth & Hayden. Write Has French taken the new notes and sent the old ones.

THE WILL OF
JOSEPH WHITING STOCK

Know all men by these presents that I Joseph W. Stock of the town of Springfield in the county of Hampden and State of Massachusetts, artist considering the uncertainty of life and being of sound mind and memory, do make, declare, and publish, this my last will and testament. First, I give and bequeath unto my sister, Mary C. Cooley, the house and lot where she now resides for her sole use and behoof on condition that she pays four several notes of hand of one hundred dollars each given by me to Luther Colton of Long Meadow bearing date Aug. 1st 1854, and also pay to my mother Martha Stock One Hundred and Forty Two dollars with interest. There is a Mortgage of Seven Hundred Dollars upon the property to the Springfield Five Cent Savings Institution which she will also pay or arrange satisfactorily to them.

Second, I give and bequeath to my mother Martha Stock for her sole use and behoof all the residue of my estate, real, personal or mixed. (after paying my just debts) of which I shall die siezed and possessed, or to which I shall be entitled at my decease to have and to hold the same to her, during her lifetime.

At the decease of my mother I give and bequeath the remainder to my sisters, Lavinia Sperry and Ann Jennette Stock in equal portions, on condition that they do remain and take all proper care of our beloved father and mother. I desire that my books and personal effects, may be distributed among my brothers and sisters as my mother may direct.

To Thomas H. Stock my nephew and ward pay the balance due him of a certain Bond for five hundred dollars given by me to his mother Lucy Stock for his benefit, a faithfull account of his expenses paid by me will be found in my account book. If I die possessed of a watch I desire it may be given to him.

I do nominate and appoint my Brother Isaac C. Stock, my executor of this my last will and testament.

In testimony whereof, I hereunto set my hand and seal in presence of the witnesses named below. This twenty sixth day of October Eighteen Hundred, and, Fifty four —

In presence of

Joseph W. Stock

Witnesses to the execution of the foregoing will
O. H. Cooley
Albert Litch
O. A. Seamans

Schedule of Personal Property belonging to the Estate of Joseph W. Stock, deceased, referred to in the Inventory of the Estate of Said deceased, viz.

1 carriage for exercise in the open air	$ 45.00
1 carriage for exercise in the house	5.00
3 small shell boxes & 1 dozen cushions & lots of shells	11.00
1 large black trunk	2.50
" common vessel color do.	1.00
" plaster Phrenological head	.12
5 bottles of Canada Mineral Water	.12
1 Dr. Mattson's pocket injecting instrument	1.50
4 packing Boxes	1.25
1 Back gammon Board	.75
" Flute	.16
	68.40

Paintings

The Horse Bargain	20.00
Lady Sketching	10.00
Scene on the Ohio River	3.00
The Pirate's Cave & Frame	10.00
View of Port Jervis, (Partly finished)	5.00
Portrait of Miss Sarah Fay	3.00
" " Henry Simons	.75
" " Mr. Daniel Lombard	5.00
" " Rev. Henry Lee (½ Cooley's)	3.75
" " L. J. Holt's child	1.00
" " Dr. White's child	1.00
" " Erastus Bates	.75
" " Rev. Mr. Mandel	1.00
" " Madison Fletcher	1.00
" " James Durfee	1.00
" " Old Gent name unknown	1.00
" " Washington	3.50
" " Col. Hatch in frame	2.00
Amount Carried forward	$ 71.75

Amount Brought forward	$ 71.75
Portrait of Mrs. Morse's children	1.00
2 Portraits — Houglands children — unfinished	2.00
The Schooner Frances A. Seward in a gale	5.00
" " " " " " " calm	5.00
The Spanish Peasant Boy	.50
Picture of Lady at the Bath	2.00
Small painting of an Indian	.50
Eight Small pictures on pasteboard	2.00
A lot (50 or 60) of Crayon Heads on oiled paper	4.00
132 Engravings of Port Jervis (4 or 5 colored)	22.66
	$116.42

Painting Materials

Tin box for keeping paints, oils, brusher & c	1.50
Old chest formerly used for the same purpose	.25
Two easels	.25
Two palette boards	.75
Two bottles of Ultramarine Ashes	1.00
One bottle of Pink Madder	2.00
Six small cans, containing oils and varnishs	.18
Three large " " " " Turpentine	1.00
Three Palette Knives	1.00
65 Brushes that have been used	4.00
46 Tubes — of paint partly used	3.00
2 Eye Glasses	.50
54 Tubes of Paint not used	5.00
24 brushes not used	2.00
11 Tin Boxes containing dry colors	3.00
27 Papers of dry colors	4.00
Glass — Hat and millar	2.00
82 Sheets of Drawing Paper	2.00
8 — 25 x 30 Canvass	5.77
2 — 18 x 24 "	1.25
Amount Carried forward	$40.45

Amount brought forward	$40.45
3 — 22 x 30 Canvass	2.12
2 — 30 x 36 "	2.00

2 — 34 x 38 "	3.32
4 Small canvass	1.00
8 Small Sketching Boards	1.50
4 Pieces of " "	.12
1 Small Roll of Canvass	1.00
2 Small gilt Frames	5.00
3 Boxes of pencils (for drawing)	1.00
A few sheets Monochromatic drawing paper	.50
2 Boxes of Crayons	2.00
1 Rosewood Frame and Picture	.75
	$58.76

Jewelry

1 Gold Watch	20.00
" " Pencil & Pen	3.00
3 " Rings	2.00
1 Small breastpin	.06
2 Full sets of Upper Teeth	10.00
	$35.06

Library

Webster's Large Dictionary	5.00
Shakespeare's Plays	.50
Young's Night Thoughts	.17
French Revolution in 2 volumes	1.50
Artist Life by Tuckerman	.25
Pilgrimage of a Pilgrim	.17
An Argument for Christianity	.12
History of the United States	.20
Gazatteer of Rhode Island & Connecticut	.12
Posephus	.50
Miscellaneous Scrap Book	.06
Amount Carried forward	$ 8.59
Amount Brought forward	$ 8.59
Haywood's Massachusetts Gazetteer	.50
Barber's Historical Collections Mass.	1.00
Water Cure Journal (bound) 1853	.50

American Phrenological Journal (bound 1851–52)	.50
Scrap Book	.25
Phrenological Journal	.75
Combe's Lectures on Phrenology	.50
Napoleon & His Marshalls in 2 Vols.	1.50
Washington and His Generals in 2 Vols.	1.50
Water Cure by Bulwer Forbes & Houghton	.75
Hydropathic Encyclopedia in 2 Vols.	1.50
Grimes Mesmerism	.50
Scrap book	.50
Ladies Companion	.33
Scientific American (bound)	.12
Gems of Art	2.50
Pictures from Grahams (bound)	2.50
Ten Numbers of the Industry of All Nations	1.00
American Phrenological Journal (unbound) 1853	.12
History of the painters of all nations in 10 Nos unbound	4.00
Bulletin of the American Art Union (8 Nos.) unbound	.25
3 Number of Art Journal	.25
Water Cure Manual	.50
Results of Hydropathy	.25
Illustrated Magazine of Art	.75
3 Numbers of Chapman's Drawing Book	.50
Painting, Sculpture & Music	.25
12 Numbers of American Scenery (unbound)	.75
Landscape painting explained in letters	.50
Consumption its prevention & cure by the water treatment	.17
Animal Chemistry	.12
Wuthering Heights, in 2 volumes — Pamphlets	.20
Amount Carried forward	$33.90

Amount Brought forward	33.90
The Green Mountain Boys	.12
Bertha & Lily	.50
Davies Shades & Shadows	.25
Perieras — Treatise on food & diet	.17
Natural laws of man	.12
Discourses on a sober & temperate life	.06
A system of vegetable diet	.12
Tobacco, its history, nature & effects on mind & body	.06

Gentlemen's Magazine Volume 2	.25
" " " 3	.25
" " " 4	.25
Graham's Magazine (bound) 1842	.50
" " " 1845	.50
" " " 1846	.50
" " " 1847	.50
" " " 1848	.50
National Portrait Gallery Vols. 3 and 4	2.00
Water Cure Journal for 1854, unbound	.12
A few no's of magazines	.12
Godey's Magazine (bound) 1848	.75
" " " 1850	.75
Peterson's Magazine " 1851	.37
" " " 1852	.37
Hydropathic Cookbook	.25
Art of Painting	.25
Lights and Shadows of Scottish Life	.12
	$43.65

Household Furniture

1 Large Cupboard painted & grained	6.00
" " " common	1.50
8 cane seat chairs much used	2.50
1 arm chair	.75
Amount carried forward	$10.75
Amount brought forward	$10.75
1 common cot bedstead	2.00
1 small lounge	.50
1 wash sink	1.50
1 small common stand	.25
1 air tight stove	.12
1 Parlor Cook Stove with pipe	4.00
1 " " " " "	1.00
1 Good Table	4.00
1 common "	1.50
1 Chest of drawers	1.50
1 Large Carpet	20.00

Three Looking glasses 2.50
One hair mattrass common size 18.00
 ———————
 $67.02

Springfield, Mass. Sept. 19th 1855
O. A. Seamans
G. W. Harrison
Edward F. Mosley
 Appraisers

Final Administration Account of Isaac C. Stock Esq. of New Haven Ct.
Executor of the last will and testament of Joseph W. Stock late of Spring-
field, County of Hampden of Commonwealth of Massachusetts, deceased
testate.
Said Executor charges himself as follows viz:

 With the amount of personal estate as per Inventory on
 file in the Probate Office in Hampden County, Mass. $389.91
 ———————
1855
Oct. 1d. With cash collected of E. Broadhead 10.00
 " " " " " " Mr. Nasen 5.00
 " " " " " " " Revinburgh 2.00
 " " " " " " " Godfrey 2.00
 " " received for furniture sold at Port Jervis N.Y. 9.87

1856
April 3. " " collected on claim of sd. Stock's estate of
 Fowler & Wells . 166.63
 " cash received of Thomas H. Stock on collections
 and sales of property-made by him in favor of
 sd. Probate 75.00
 ———————
 $270.50
 ———————
 $660.41

 Said Executor prays allowance of the following charges
 viz:

1855
June 30. Paid Wells P. Hodgett, undertaker's bill$ 24.00
Oct. 11. " for tolling bell . .75
 " " " Dr. A. W. Dufrene's bill, last sickness 20.95

"	19.	"	taxes on real estate	23.44
"	"	"	D. F. Ashley on a/c against said estate	15.38
"	"	"	Mead & Webb on claim " " "	4.39
			Amount Carried (forward.)	$ 88.35

1856			Amount of charges against sd. estate brought for-ward	$ 88.35
Dec.	22.	Paid	A. Wilson on claim against Said Estate	14.22
"	"	"	Thomas H. Stock on claim against Said Estate ...	320.75

1855

Sept.	11.	"	F. W. Crooks oath fees to appraisers25
"	18	"	Appraisers on said Estate	6.56
Oct.	12.	"	cash to O. W. Seamans for services at N. York. (Port Jervis) & other places in settling matters of Said Estate, collecting & paying bills	72.02

1856

Jany.	3.	"	Wm Rice Esq. for recording fees25
		"	cash for expenses & fares on business of sd. estate .	27.54
		"	for drawing Administration acct. and services on said Estate	5.00
				$534.94

Springfield, Mass. Jany 7th/62.

Isaac C. Stock

A CHECKLIST
OF THE PAINTINGS

I. WORKS DATED AND/OR INSCRIBED

PAINTINGS

The following works are all oil paintings on canvas. Measurements are given in inches.

1. *Frederick Merrick*, 1835
 30 x 25, Springfield
 Journal page [12]: *Frederick Merrick of Wilbraham*
 Collection of Mr. Roderick S. Merrick, Jr., Annapolis, Maryland.

2. *Miss Fedelia Griswold*, 1835
 30 x 25, Springfield
 Journal page [12]: *Miss Fedelia Griswold*
 Collection of Mr. Roderick S. Merrick, Jr., Annapolis, Maryland.
 Miss Griswold later married Frederick Merrick.

3. *Henry Bailey*, 1835
 30 x 24
 Journal page [12]: *Henry Bailey*
 Collection of Mrs. Fred S. Ball, Montgomery, Alabama.

4. *Abel Bliss*, 1836
 30 x 25, Wilbraham
 Journal page [14]: *Abel Bliss*
 Collection of Miss Mary Ellen MacLean, Wilbraham, Massachusetts.

5. *Mary Abba Woodworth*, 1837
 48 x 33, Springfield
 Journal page [17]: *Earle Woodworth's girl*
 Museum of Fine Arts, Springfield, Massachusetts.
 This painting was previously known as *Mary Amidon*.

6. *William Belden*, 1838
 30 x 25, Springfield
 Journal page [20]: *Wm. Belden*
 Collection of Mr. and Mrs. Arthur Riordan.

7. *Mrs. Belden*, 1838
 30 x 25, Springfield
 Journal page [20]: *Mrs. Belden his wife*
 Collection of Mr. and Mrs. Arthur Riordan.

8. *William Howard Smith*, 1838
 52¼ x 35⅞, Springfield
 A photograph of the original canvas before relining shows the
 　　inscription: *Wm. Howard Smith, ages 5 years 7 months.*
 　　Painted June, 1838 by J. W. Stock.
 Journal page [27]: *David Smiths son*
 Abby Aldrich Rockefeller Folk Art Collection, Williamsburg, Virginia.

9. *Mary Jane Smith*, 1838
 42 x 30½, Springfield
 A photograph of the original canvas before relining shows the
 　　inscription: *Mary Jane Smith, aged 2 yrs. 4 months.*
 　　Painted June 1838 by J. W. Stock.
 Journal page [27]: *David Smiths daughter*
 Abby Aldrich Rockefeller Folk Art Collection, Williamsburg, Virginia.

10. *Henry Ward*, 1838
 46¼ x 29, Springfield
 Journal page [20]: *Henry Ward　his son*
 Collection of Mr. William C. Boyce, Dallas, Texas.

11. *Lucy Gould Stock*, 1839
 30 x 25, Cabotville
 Journal page [25]: *Mrs. Luther Stock*
 Connecticut Valley Historical Museum, Springfield, Massachusetts.

12. *Luther Stock*, 1840
 30 x 25, Springfield
 Journal page [26]: *Luther Stock*
 Connecticut Valley Historical Museum, Springfield, Massachusetts.

13. *Thomas Henry and Wilber Fisk Stock*, 1840
 46 x 36, Springfield
 Journal page [26]:
 　　Thomas H. Stock, his son
 　　Wilber Fisk Stock　"
 Connecticut Valley Historical Museum, Springfield, Massachusetts.
 The boys of this painting were the children of Luther and Lucy Stock.

14. *E. H. Dickerman*, 1840
 30 x 25, New Haven, Connecticut
 Inscription on back of canvas: *By J. W. Stock June 1840*
 Journal page [27]: *E. H. Dickerman*
 Collection of Mr. and Mrs. Arthur Riordan.

15. *John and Albert Pardee*, 1840
 48 x 36, New Haven
 Journal page [28]:
 John his son
 Albert his son
 Collection of E. Hatch, Greenwich, Connecticut.

16. *John Stock*, 1841
 30 x 25, Springfield
 Journal page [30]: *John Stock my father*
 Museum of Fine Arts, Springfield, Massachusetts.

17. *Martha Whiting Stock*, 1841
 30 x 25, Springfield
 Journal page [30]: *Patty Stock my mother*
 Museum of Fine Arts, Springfield, Massachusetts.

18. *Jane Tyler*, 1841
 39¾ x 30, Springfield
 Journal page [32]: *Lucius Tyler's Daughter*
 Collection of Mr. and Mrs. Peter Tillou, Litchfield, Connecticut.

19. *Captain J. L. Gardner's son*, 1842
 45 x 36, Bristol, Rhode Island
 Inscribed on back of canvas: *Pted Bristol R. Island, 1842*
 Journal page [36]: *Capt. J. L. Gardner's son*
 Collection of Mr. and Mrs. John B. Schorsch, Pennsylvania.

20. *Self-Portrait*, 1842
 10 x 8 (oval), New Bedford
 Inscribed on back of canvas: *february 25, 1842, J. W. Stock*
 Journal page [57]: *J W Stock*
 Connecticut Valley Historical Museum, Springfield, Massachusetts.

21. *Captain H. Shockley*, 1842
 30 x 25, New Bedford
 Journal page [57]: *Capt. H. Shockley*
 Old Dartmouth Historical Society, New Bedford, Massachusetts.

22. *Elisha Wales*, 1843
 46 x 38, East Randolph
 Inscribed on stretcher: *E. L. Wales ae 2 yrs Taken by J. W. Stock*
 Sept. 1843
 Journal page [59]: *Elisha Wales Cousin*
 Collection of Dr. and Mrs. Ralph Katz, Williamsville, New York.

23. *Jasper Raymond Rand*, 1844
 46 x 40½, Westfield
 Journal page [63]: *Jasper R. Rand son*
 The Newark Museum, Newark, New Jersey.

24. *Addison C. Rand*, 1844
 46½ x 38, Westfield
 Journal page [63]: *Addison son*
 Collection of Thayer A. Greene, Pleasantville, New York.

25. *Albert T. Rand*, 1844
 30 x 25, Westfield
 Journal page [62]: *Albert son*
 Collection of Theodore P. and Mary J. Greene,
 Amherst, Massachusetts.

26. *The Young Hammerer*, 1844
 30 x 25, Springfield
 Inscribed on back of canvas: *Died Feb. 19th. 1844 aged 1 yr. 8 mo.*
 2 days Painted By J. W. Stock
 New York State Historical Association, Cooperstown, New York.

27. *Eugene Judd*, 1844
 30 x 25, Springfield
 Journal page [62]: *Eugene Judd, Southampton*
 Collection of Mr. and Mrs. Oliver Deming.

28. *Jane Henrietta Russell*, 1845
 48¼ x 36¼, Westfield
 Inscribed on canvas: JANE HENRIETTA RUSSELL
 Inscribed on back of canvas: *By J. W. Stock 1844*
 Journal page [64]: *Henrietta Russell corpse*
 Shelburne Museum, Shelburne, Vermont.

29. *Helen Eddy*, 1845
 40½ x 28, Springfield
 Journal page [66]
 Privately owned.

30. *Mary and Francis Wilcox*, 1845
 48 x 40, Springfield
 Journal page [65]:
 Francis & Mary Wilcox in group
 deceased children of P. F. Wilcox

National Gallery of Art, Gift of Edgar William and
Bernice Chrysler Garbisch, 1959.

31. *Francis Wilcox*, 1845
26 x 21, Springfield
Journal page [65]: *Francis Wilcox duplicate*
Collection of Mr. and Mrs. R. Duncan Clapp, Sarasota, Florida.

32. *Mary Wilcox*, 1845
26 x 21, Springfield
Journal page [65]: *Mary Wilcox duplicate*
Collection of Mr. and Mrs. R. Duncan Clapp, Sarasota, Florida.

33. *Elihu Mott Mosher*, 1845
29 x 24½, New Bedford
Inscribed on back of canvas: *Elihu M. Mosher at the age of 21 years,
 New Bedford Mass. Painting by John [sic] Stock June 1845, portrait
 painter of Springfield, Mass.*
Collection of Dr. and Mrs. John M. Graether, Marshalltown, Iowa.

34. *Mary Child*, 1846
44 x 36, Springfield
Journal page [69]: *Charles Child's daughter Mary*
The Margaret Woodbury Strong Museum, Rochester, New York.

35. *Theodore Besse*, 1846
40 x 32, New Bedford
Journal page [72]: *Theodore Besse*
Old Dartmouth Historical Society, New Bedford, Massachusetts.

36. *Humphrey H. Soule*, 1846
30 x 25, New Bedford
Inscribed on back of canvas: *Humphrey H. Soule*
Journal page [71]: *H. Soule*
Old Dartmouth Historical Society, New Bedford, Massachusetts.

37. *Captain Stephen Christian*, 1847
30 x 25, New Bedford
Inscribed on back of canvas: *Painted By J. W. Stock New Bedford.
 May 1847 Stephen Christian aged 40 yrs.*
Old Dartmouth Historical Society, New Bedford, Massachusetts.

38. *Asenath C. Farnum*, 1855
35⅜ x 28⅛
Mentioned in letter of Stock to Otis Cooley dated January 7, 1855: "I

have engaged over $120 in portraits for some of the best families in
the place so I think it will had in others. Mr. Farnum & wife, the one
that own the place with the Fountain . . . will have their portraits
painted."
The New-York Historical Society, New York, New York.

39. *Samuel B. Farnum*, 1855
 35⅜ x 28⅛
 The New-York Historical Society, New York, New York.

40. *The Farnum Children*, 1855
 49½ x 39⅝
 The New-York Historical Society, New York, New York.

MINIATURES

The following works are all oil paintings on
ivory. Measurements are given in inches.

41. *John Houle*, 1841
 2¼ x 1¾
 A photograph of the back of the miniature shows the following inscrip-
 tion which was removed during necessary restoration: *J. W. Stock*
 pinxt Warren Dec. 1841 John Houle Aged 20 years 4 mos
 Connecticut Valley Historical Museum, Springfield, Massachusetts.

42. *William Reed*, 1842
 2¾ x 1¾
 Inscribed on back: *Painted by J. W. Stock New Bedford Nov 1842*
 Journal page [57]: *Mr. William Reed*
 Connecticut Valley Historical Museum, Springfield, Massachusetts.

43. *Child in Red Dress*
 4 x 3
 Mr. and Mrs. Edgar D. Nelson

44. *Child in White Dress*
 4¼ x 3¼
 Inscribed on back at a later date:
 New London, Ct. Painted by Stock
 Ca. 1835.
 Mr. and Mrs. Edgar D. Nelson.

LITHOGRAPH

45. *Port Jervis N.Y.*, ca. 1854
 27 inches x 16 inches
 The New-York Historical Society, New York, New York.

II. WORKS ATTRIBUTED TO STOCK
with approximate dates

PAINTINGS

The following works are all oil paintings on canvas. Measurements are given in inches.

1. *Roxana Merrick*, early 1830s
 30 x 25
 The Merrick Family, Wilbraham, Massachusetts.

2. *Unknown Woman of the Merrick Family*, early 1830s
 30 x 25
 The Merrick Family, Wilbraham, Massachusetts.

3. *Unknown Man of the Root Family*, early 1830s
 30 x 25
 Collection of Mrs. Lewis Miller, Southampton, Massachusetts.

4. *Unknown Woman of the Root Family*, early 1830s
 30 x 25
 Collection of Mrs. Lewis Miller, Southampton, Massachusetts.

5. *Phoebe Bliss*, ca. 1836
 30 x 25
 Collection of Miss Mary E. MacLean, Wilbraham, Massachusetts.
 The portrait of Abel Bliss, her husband (checklist I:4), is recorded in
 the journal on page [14].

6. *Abraham Avery*, 1836
 30 x 25
 Journal page [14]: Abraham Avery
 Wilbraham Academy, Wilbraham, Massachusetts.
 Although the name of Abraham Avery does appear in the journal, this
 painting is attributed to Stock only for stylistic reasons.

7. *Unknown Man*, 1837
 27¼ x 22¼
 Mr. and Mrs. Philip J. Domenico.

8. *Unknown Woman*, late 1830s
 27¼ x 22¼
 Mr. and Mrs. Philip J. Domenico.

9. *Child with a Spoon*, late 1830s
 19½ x 15 (oval)
 Wadsworth Atheneum, Hartford, Connecticut,
 The Ella Gallop Sumner and Mary Catlin Sumner Collection.

10. *Miss Gilmore*, late 1830s
 37 1/3 x 30
 Collection of E. Hatch, Greenwich, Connecticut.

11. *Baby in a Wicker Basket*, 1840s
 30 x 25
 Collection of Edgar William and Bernice Chrysler Garbisch.

12. *Boy with a Toy Horse*, 1840s
 50½ x 40
 The New-York Historical Society, New York, New York.

13. *Boy with his Pet Dog*, 1840s
 49 x 40
 Collection of Dr. Nathan S. Kline, New York, New York.

14. *The Fisherman with His Dog*, 1840s
 48 x 36
 Museum of Fine Arts, Springfield, Massachusetts.

15. *Unknown Boy in a Blue Dress*, 1840s
 45 x 36
 Shelburne Museum, Shelburne, Vermont.

16. *Nancy Riley*, 1840s
 44 x 36
 Collection of George J. and Patricia Arden, New York, New York.

17. *Girl in a Blue Dress with Her Pet Dog*, 1840s
 30 x 25
 Collection of Mr. and Mrs. Peter Tillou, Litchfield, Connecticut.

18. *Unknown Bearded Man*, 1840s
 30 x 25
 Old Dartmouth Historical Society, New Bedford, Massachusetts.
 This painting was probably painted in New Bedford between 1841 and
 1843 or in 1846.

19. *Mrs. Eliza S. Clapp*, ca. 1845
 29¾ x 25
 Collection of Dr. and Mrs. John M. Graether, Marshalltown, Iowa.

This portrait is linked with that of Elihu Mosher (Checklist I:33). The information that has been passed down is that Eliza was nineteen years old in this painting and that she was the daughter of Elihu Mosher. Probably she was the sister of the Elihu Mosher of the painting, whose father was also named Elihu.

20. *Unknown Woman,* late 1840s
 29 x 24 (oval)
 Collection of Mr. and Mrs. Robert B. McTaggart.
 This portrait has for many years been accepted as that of Annjanette Stock, Joseph Stock's sister.

21. *Miss Thayer,* late 1840s
 30 x 25
 Collection of Mr. and Mrs. Oliver Deming.
 Miss Thayer's twin, also known only as Miss Thayer, is listed below.

22. *Miss Thayer,* late 1840s
 30 x 25
 Collection of Mr. and Mrs. Oliver Deming.

23. *Unknown Young Girl,* late 1840s
 Pastel on paper
 21⅛ x 17
 Collection of Mr. and Mrs. Robert M. Felton.

24. *Daniel Plumb,* late 1840s–1850
 30 x 25
 Collection of James and Catherine Perkins, East Hampton, New York.

25. *Mrs. Daniel Plumb,* late 1840s–1855
 30 x 25
 Collection of James and Catherine Perkins, East Hampton, New York.

26. *Daniel Plumb, Jr.,* late 1840s–1855
 30 x 25
 Collection of James and Catherine Perkins, East Hampton, New York.

27. *Girl in Pink Dress,* late 1840s–1855
 30 x 25
 Collection of Mr. and Mrs. Peter Tillou, Litchfield, Connecticut.

28. *The Blaksley Boys,* ca. 1845
 52 x 36
 Missouri Historical Society, St. Louis, Missouri.

29. *Seated Baby with Rattle*, ca. 1850s
 30 x 25
 Mrs. Mae Cooley Hadcock.

30. *Horace Wilson Eddy*, ca. 1840s
 40½ x 28
 Privately owned.

31. *Unknown Man*, ca. 1840
 30 x 24
 Mr. and Mrs. Edward M. Ferry, Amherst, Massachusetts.

32. *Seated Baby with Cat*, ca. 1850s
 30 x 25
 Bernard M. Barenholtz Collection.

33. *Edward C. Corwin*, ca. 1850s
 30 x 25
 The New-York Historical Society, New York, New York.

34. *Mrs. Edward C. Corwin*, ca. 1850s
 30 x 25
 The New-York Historical Society, New York, New York.

35. *William N. Coleman*, ca. 1850s
 30 x 24¾
 Patricia Silleck.

36. *Margaret E. Coleman*, ca. 1850s
 Patricia Silleck.
 30 x 24¾

37. *Olever B. Coleman*, ca. 1854
 30 x 25
 On stretcher: "Olever B. Coleman. Age 6 yrs"
 Privately owned.

38. *Portrait of a Man*, ca. 1850s
 29 x 24
 The Art Museum, Princeton University, Princeton, New Jersey.

39. *Miss Clark*, ca. 1840
 28 x 25
 Mr. and Mrs. Samuel Schwartz, Paterson, New Jersey.

40. *Roxanne C. and Charles Carroll Ray*, ca. 1844
 46 x 30
 Abby Aldrich Rockefeller Folk Art Collection, Williamsburg, Virginia.

41. *Daniel Webster*, ca. 1850
 30 x 25
 Privately owned.

42. *Edmund Seely*, ca. 1850
 44 x 38
 Privately owned.
 The child Edmund was three years old at the time of the painting.

43. *Henry Clay*, ca. 1854
 30 x 25
 Privately owned.

44. *Martha Randall*, ca. 1845–1850
 48 x 34½
 Collection of Mr. and Mrs. Arthur Riordan.

45. *Child with Cat*, late 1830s
 31 x 23¼
 Collection of Mr. and Mrs. Robert J. Farrell.

Miniatures

The following works are all oil paintings on ivory. Measurements are given in inches.

46. *Unknown Young Woman*
 2½ x 2⅛
 Connecticut Valley Historical Museum, Springfield, Massachusetts.
 This miniature was given to the Museum by the artist's great-grand-nieces when they gave the journal.

47. *Unknown Young Man*
 2 3/5 x 2
 Connecticut Valley Historical Museum, Springfield, Massachusetts.
 This miniature was given to the Museum by the artist's great-grand-nieces when they gave the journal.

48. *Unknown Young Man with a Pocket Watch*
 2½ x 1 15/16
 Collection of Mr. and Mrs. Oliver Deming.

49. *Unknown Man*
 2½ x 2
 Old Dartmouth Historical Society, New Bedford, Massachusetts.

50. *Unknown Man*
 2½ x 2
 Old Dartmouth Historical Society, New Bedford, Massachusetts.

51. *Unknown Man*
 2½ x 2
 Old Dartmouth Historical Society, New Bedford, Massachusetts.

52. *Unknown Man*
 2½ x 2
 The Rhode Island Historical Society, Providence, Rhode Island.

53. *Young Child*
 2½ x 2
 Collection of George E. Schoellkopf Gallery, New York, New York.

54. *Young Child*
 2½ x 2
 Collection of George E. Schoellkopf Gallery, New York, New York.

55. *Two Children*
 2 x 2⅜
 Mr. and Mrs. Samuel Schwartz, Paterson, New Jersey.

56. *Unknown Child in White Dress Holding Flowers*
 2¾ x 1⅝
 Collection of Mrs. Lucy B. Mitchell, Longmeadow, Massachusetts.

*The following three oil paintings on canvas
are all attributed to Stock, but the present
location of each is unknown. Measurements
are given in inches.*

Jane Frances and Emily E. Gray, ca. 1845
42 x 36
Ex-Museum of Fine Arts, Springfield, Massachusetts.
Jane Frances Gray was the wife of Henry Gray, who was listed in the
 journal on page [68]. His portrait has not survived, and the portrait
 of his wife and daughter was not recorded in the journal.

Susan Child, late 1840s

44 x 36

Illustrated in *American Primitive Painting*, Jean Lipman, Oxford University Press, New York, 1942.

A photograph of this painting is also on file at the Frick Art Reference Library. This painting was probably a companion portrait to Mary Child's portrait (checklist I:33).

Mary Caroline and Otis Hubbard Cooley, 1850–1852

41 x 37½

Ex-Edith Halpert Collection

The children of this painting were Stock's niece and nephew, the daughter and son of his sister Mary and her husband Otis Cooley, the daguerreotypist who was in partnership with Stock.

THE PAINTINGS

OF JOSEPH WHITING STOCK

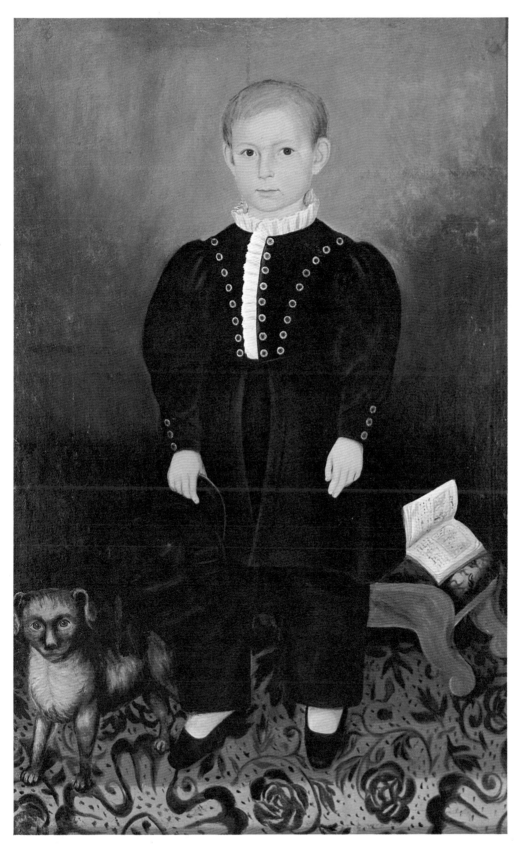

Henry Ward [I:10]

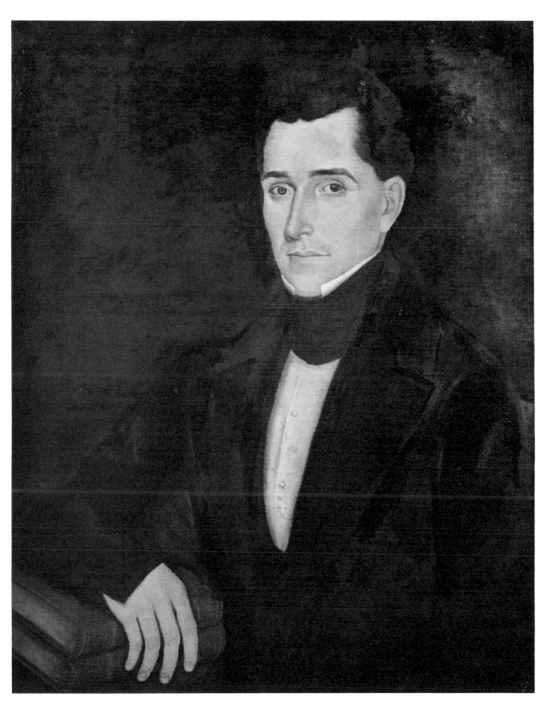

Frederick Merrick [I:1]

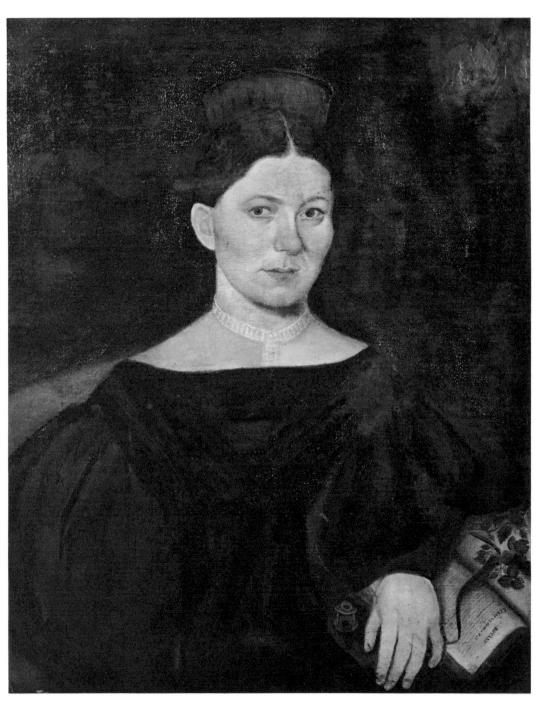

Miss Fedelia Griswold [I:2]

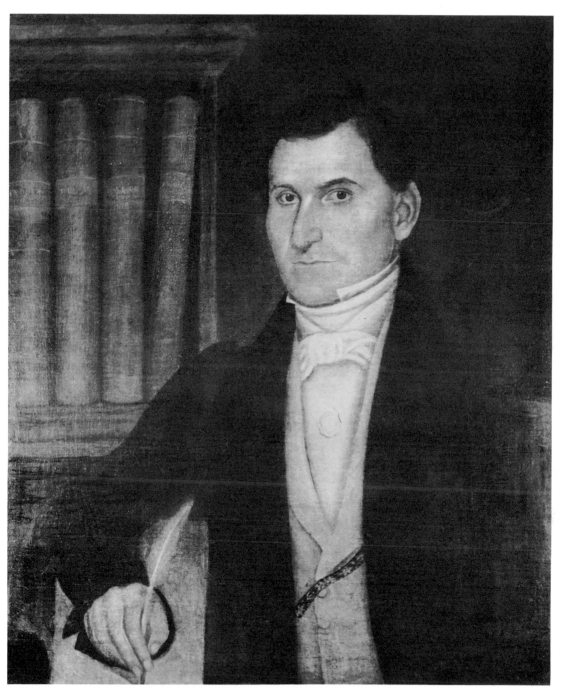

Henry Bailey [I:3]

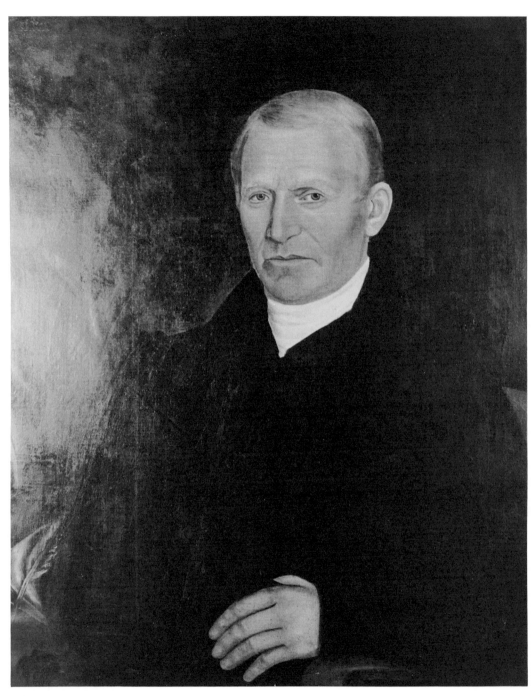

Abel Bliss [I:4]

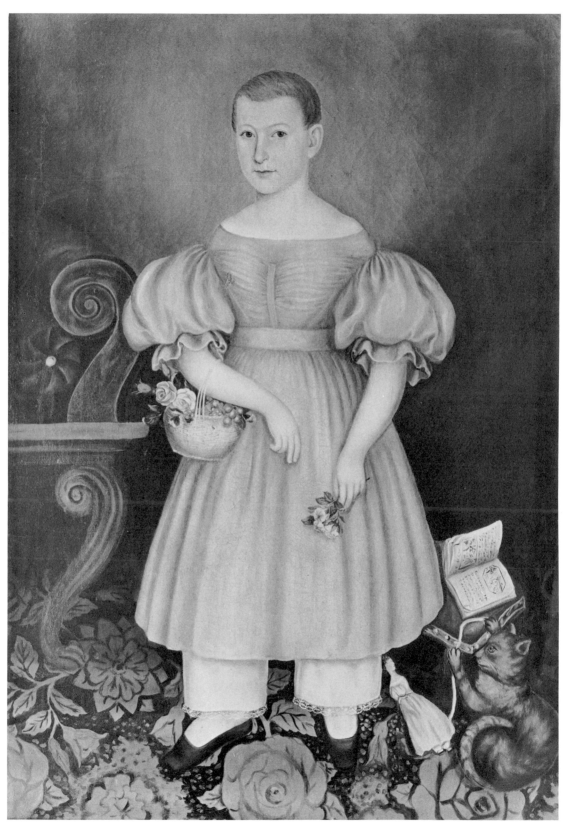

Mary Abba Woodworth [I:5]

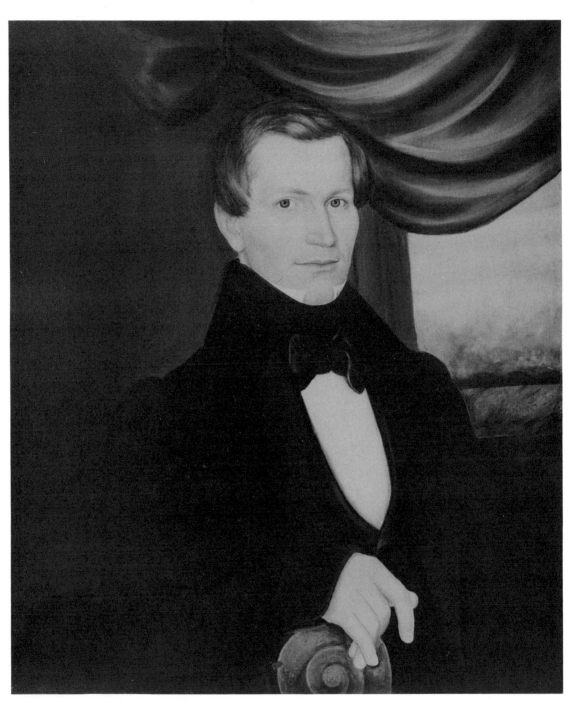

William Belden [I:6]

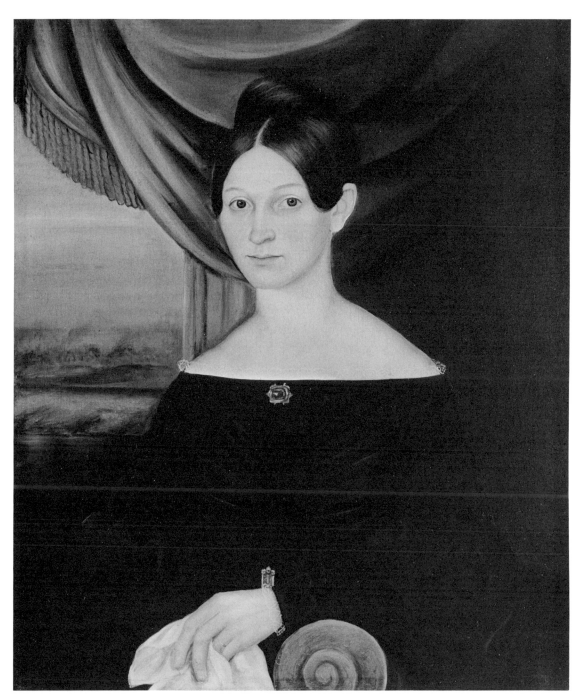

Mrs. Belden [I:7]

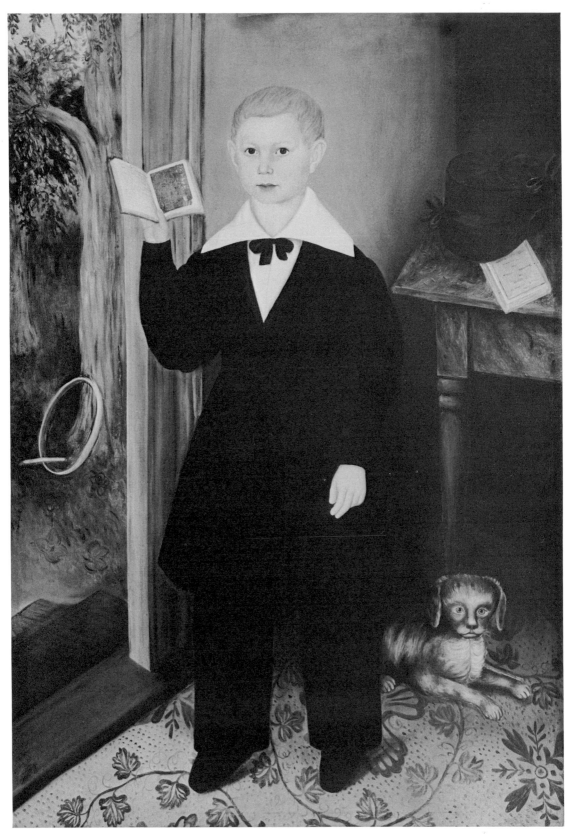

William Howard Smith [I:8]

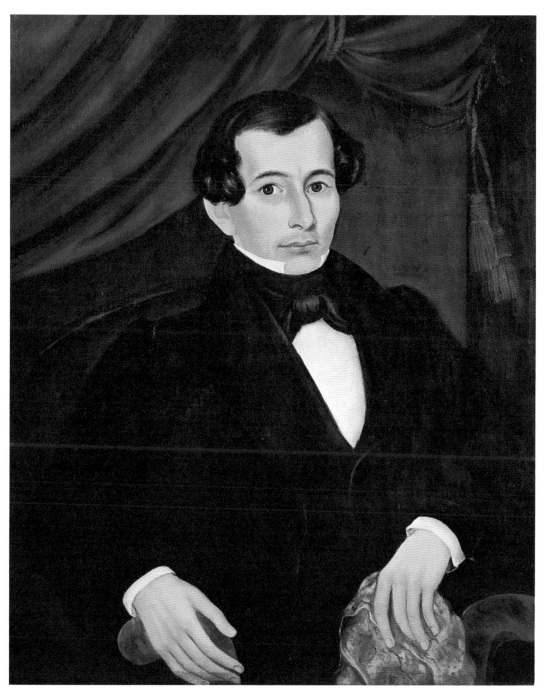

E. H. Dickerman [I:14]

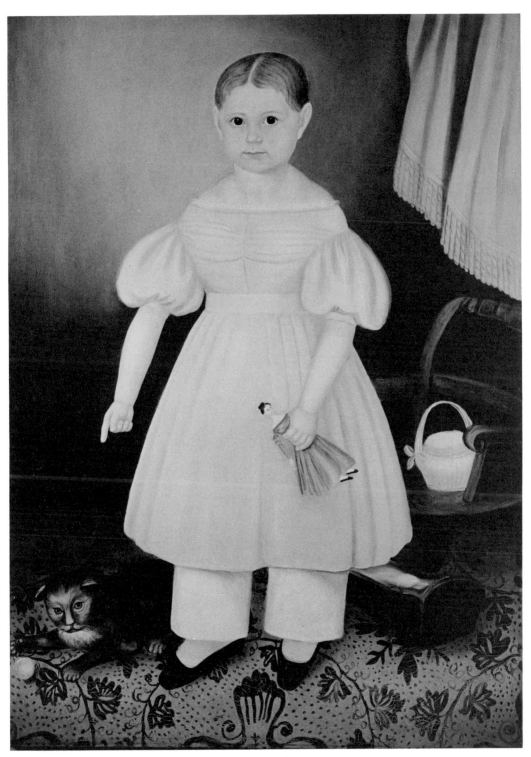

Mary Jane Smith [I:9]

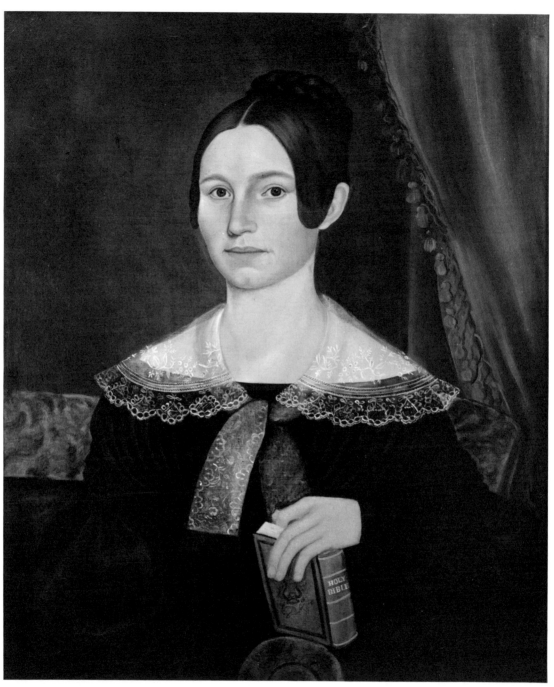

Lucy Gould Stock [I:11]

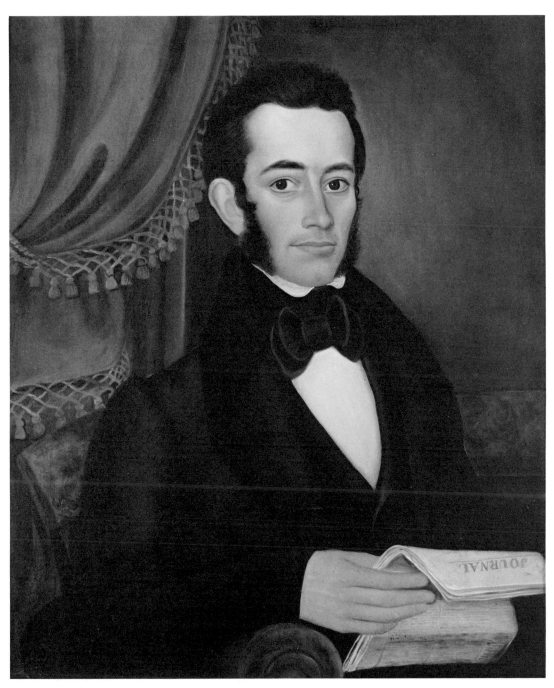

Luther Stock [I:12]

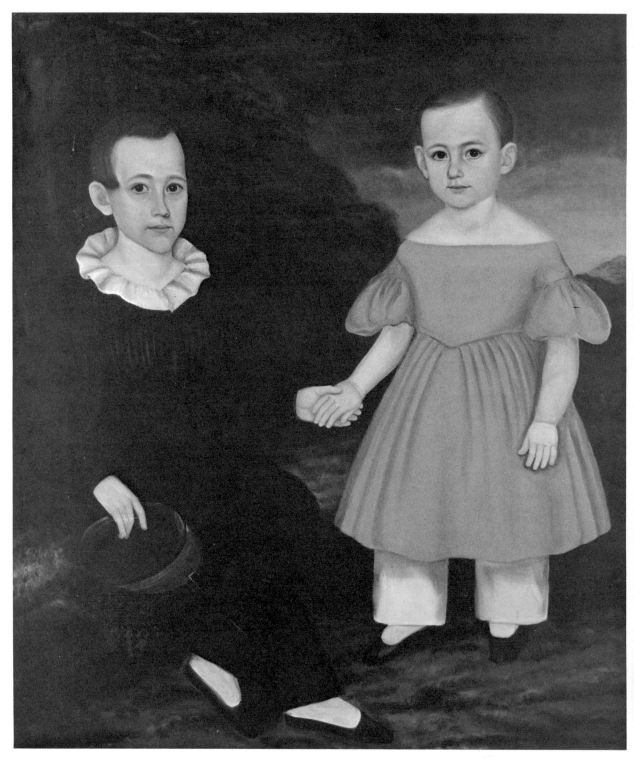

Thomas Henry and Wilbur Fisk Stock [I:13]

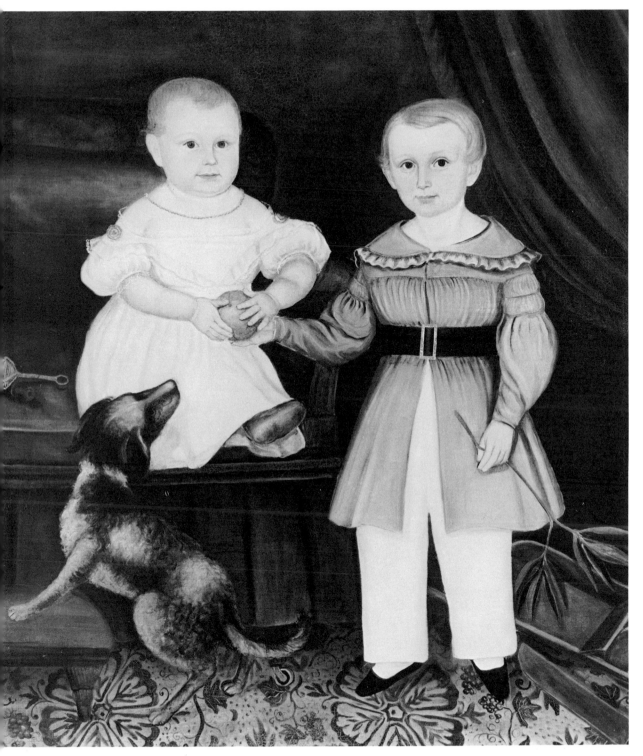

John and Albert Pardee [I:15]

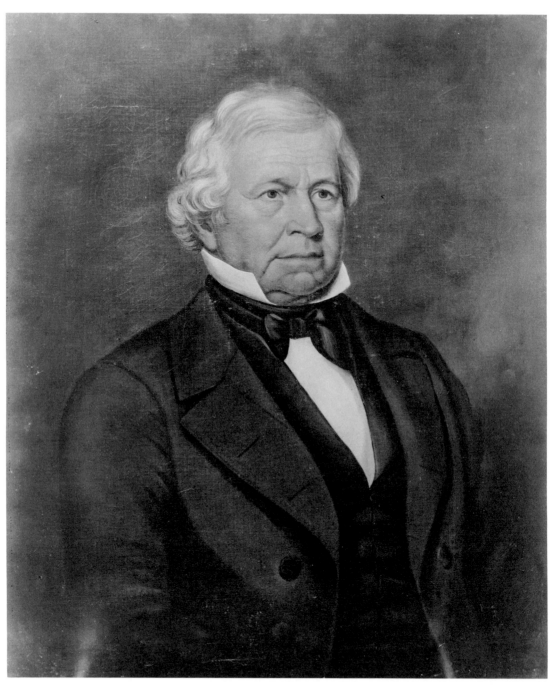

John Stock [I:16]

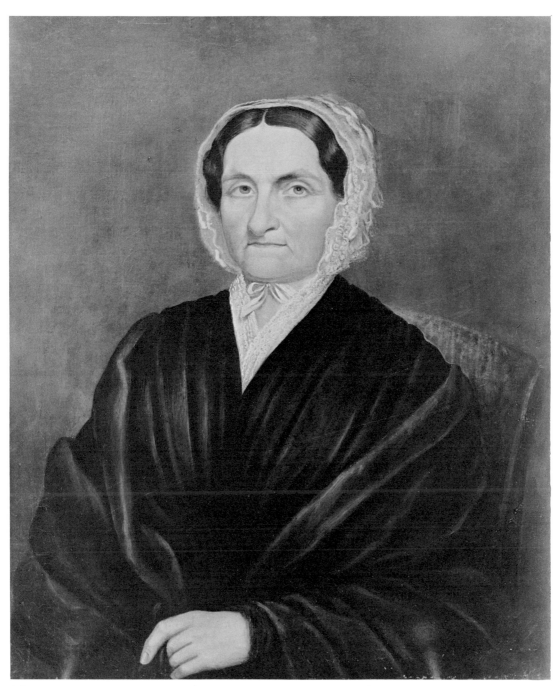

Martha Whiting Stock [I:17]

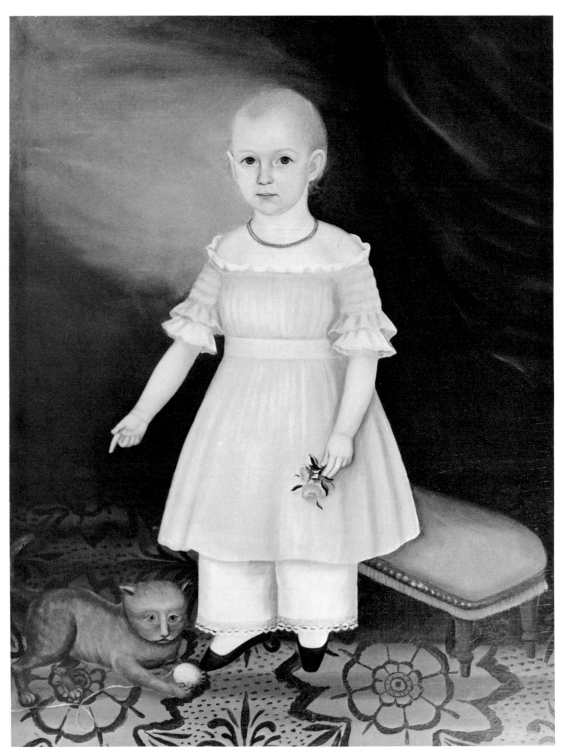

Jane Tyler [I:18]

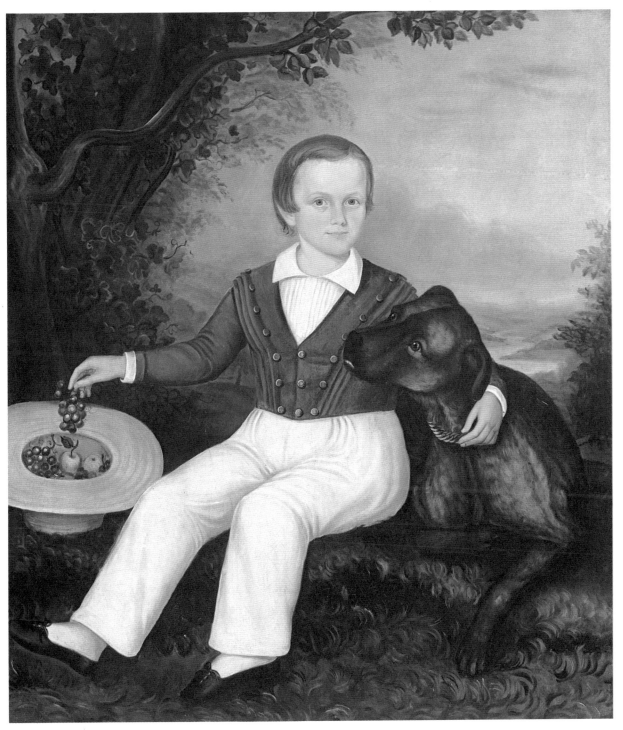

Jasper Raymond Rand [I:23]

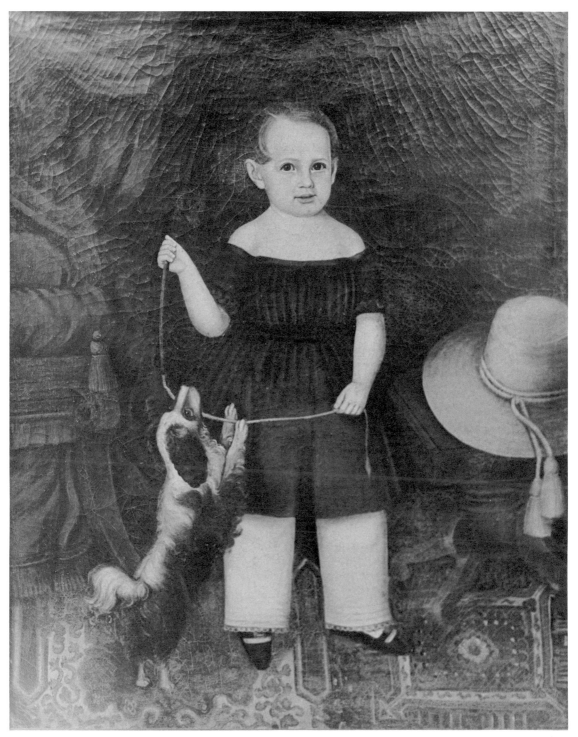

Captain J. L. Gardner's son [I:19]

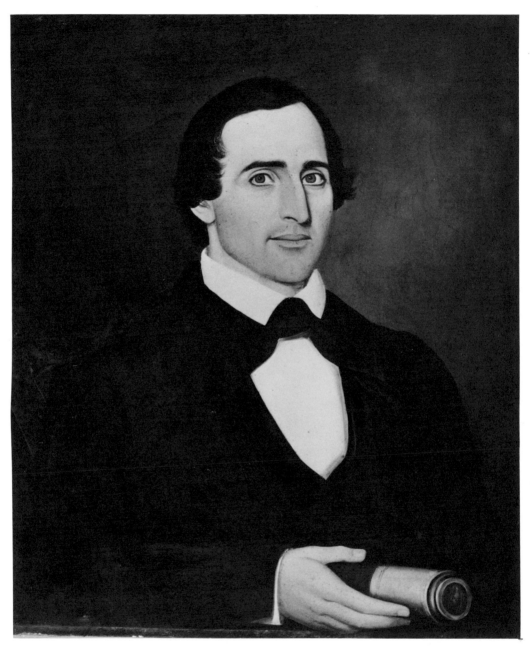

Captain H. Shockley [I:21]

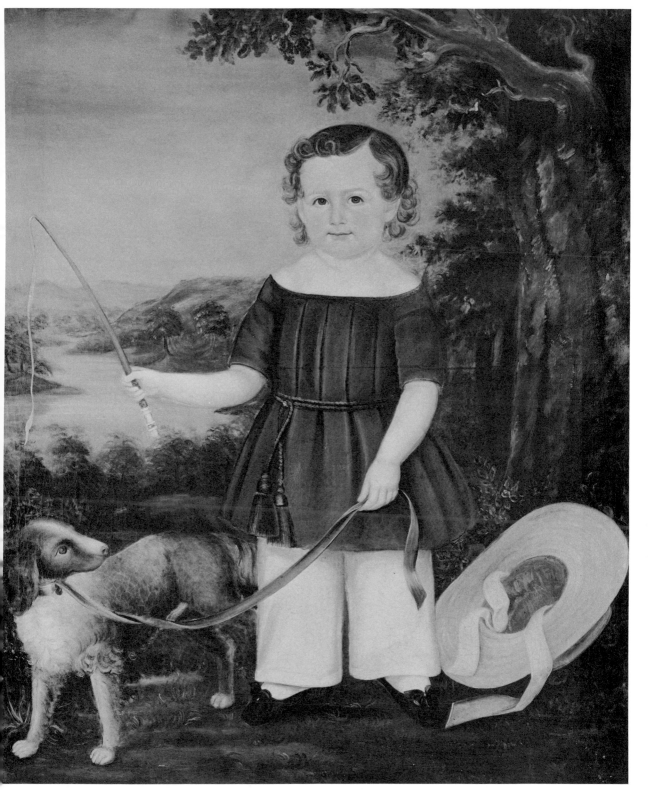

Elisha Wales [I:22]

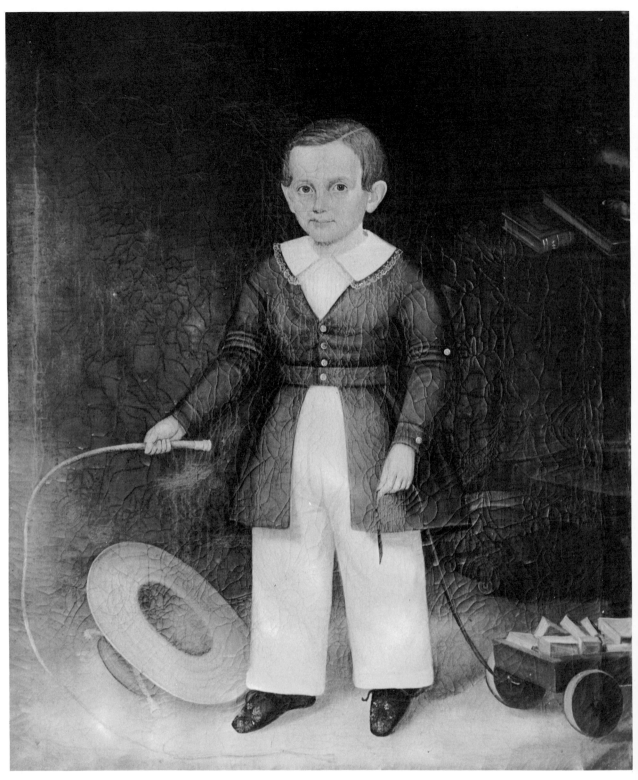

Addison C. Rand [I:24]

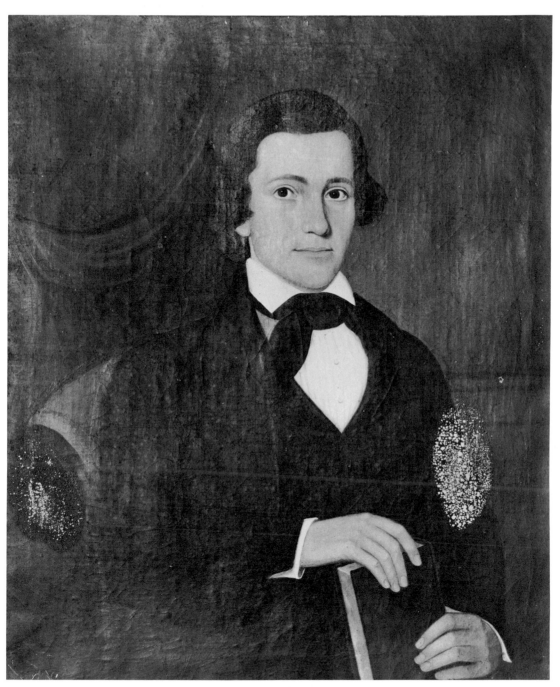

Albert T. Rand [I:25]

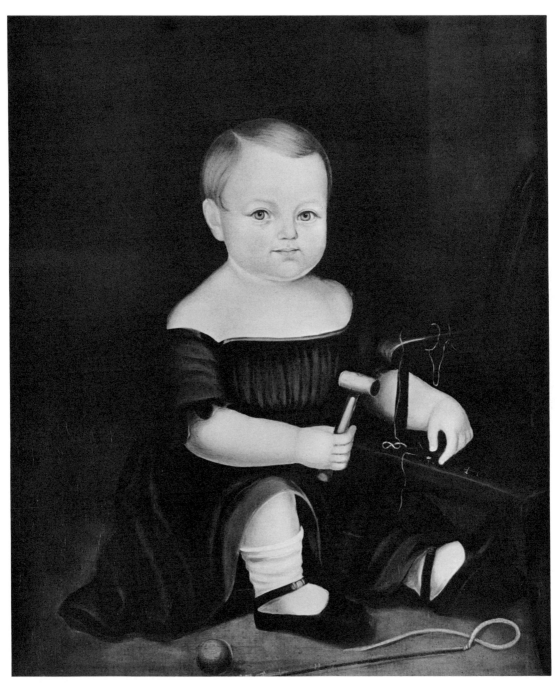

The Young Hammerer [I:26]

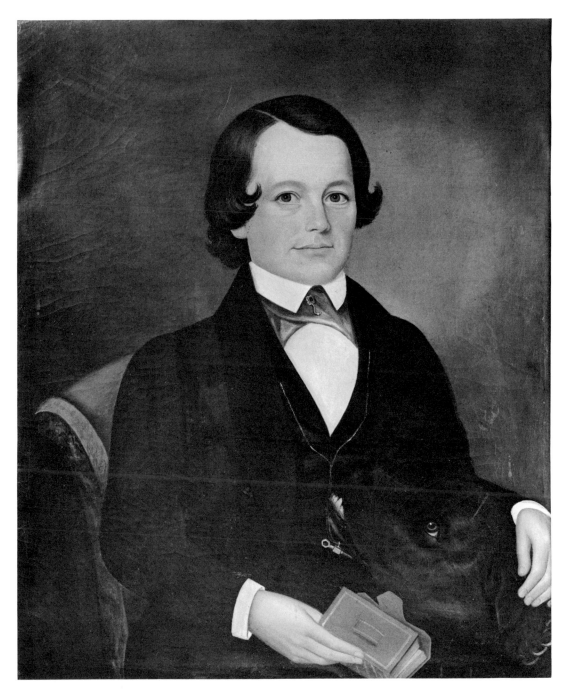

Eugene Judd [I:27]

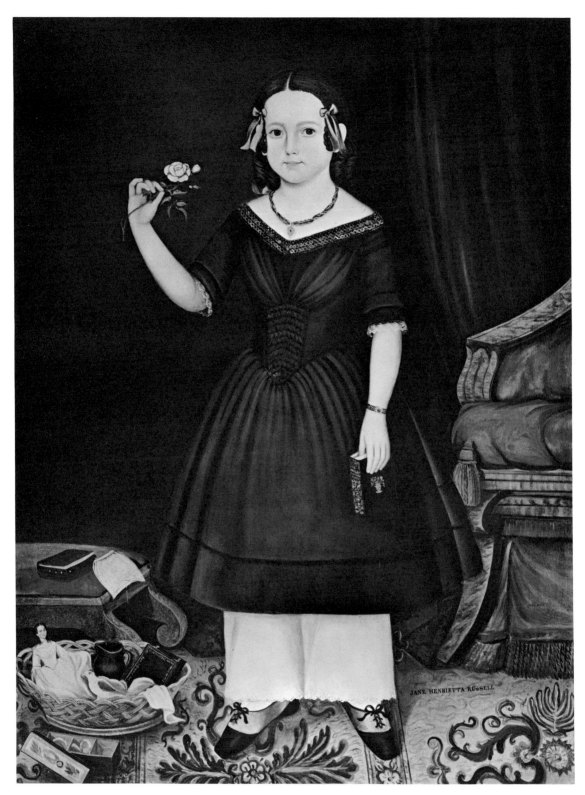

Jane Henrietta Russell [I:28]

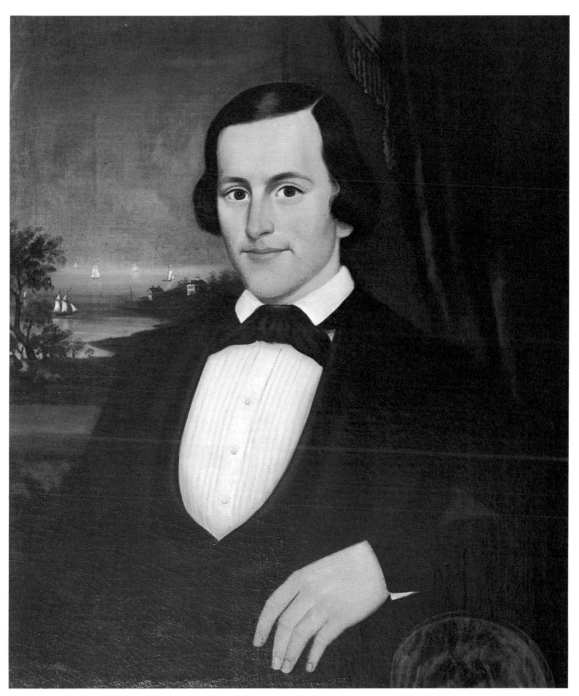

Elihu Mott Mosher [I:33]

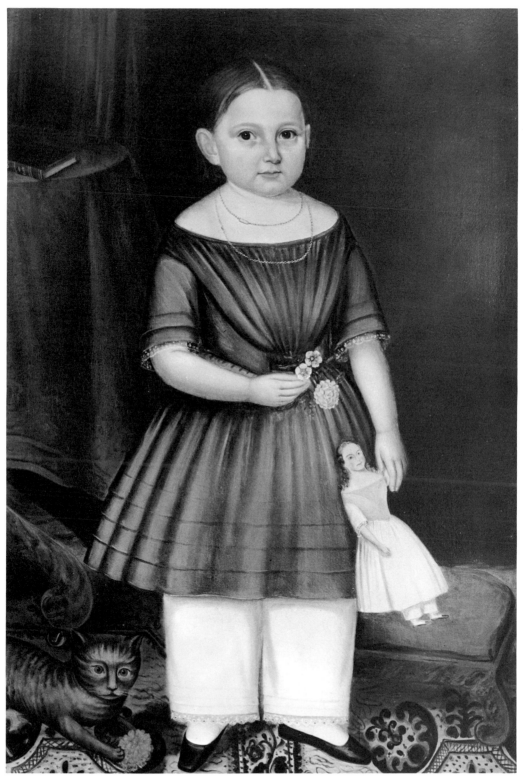

Helen Eddy [I:29]

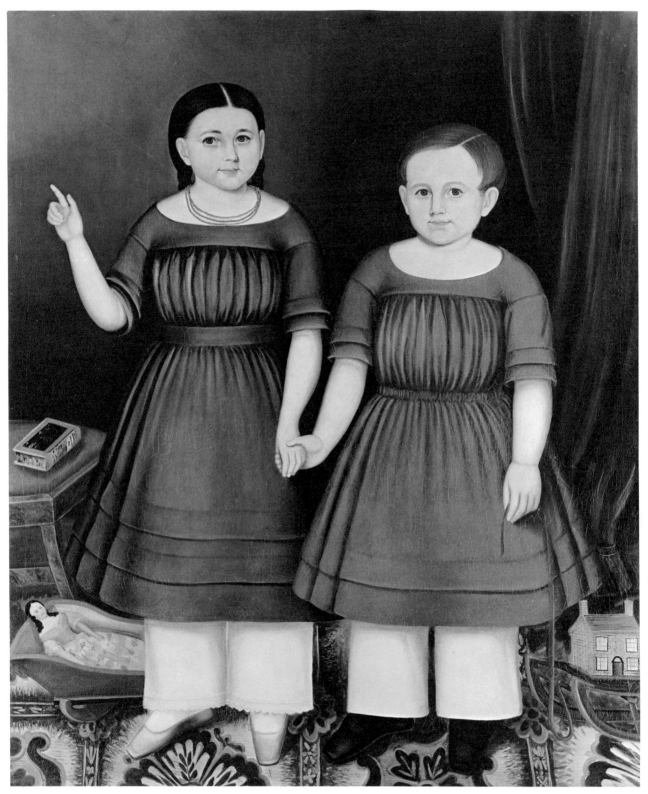

Mary and Francis Wilcox [I:30]

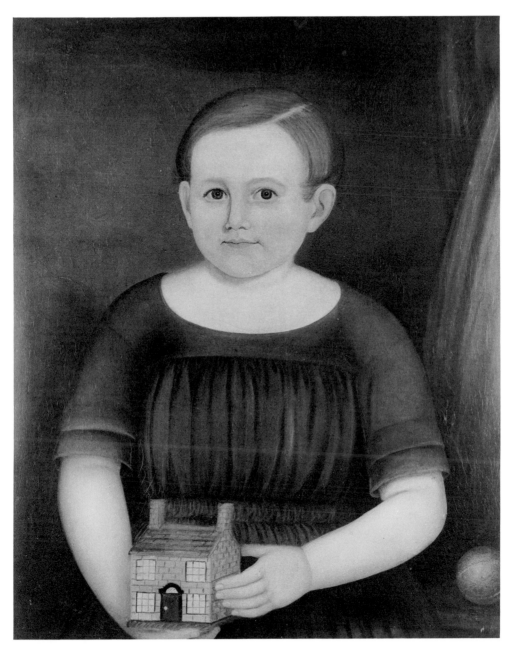

Francis Wilcox [I:31]

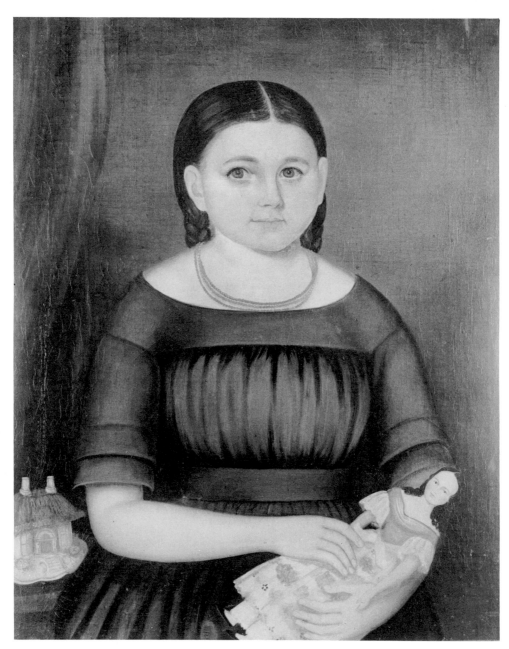

Mary Wilcox [I:32]

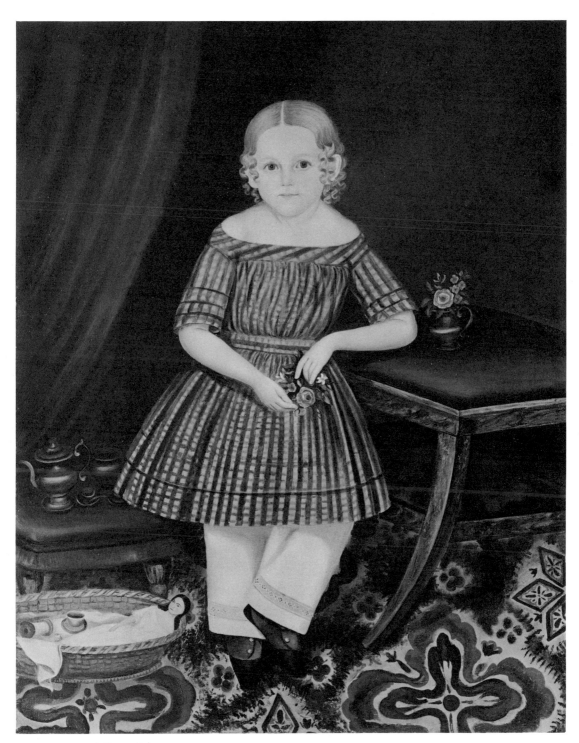

Mary Child [I:34]

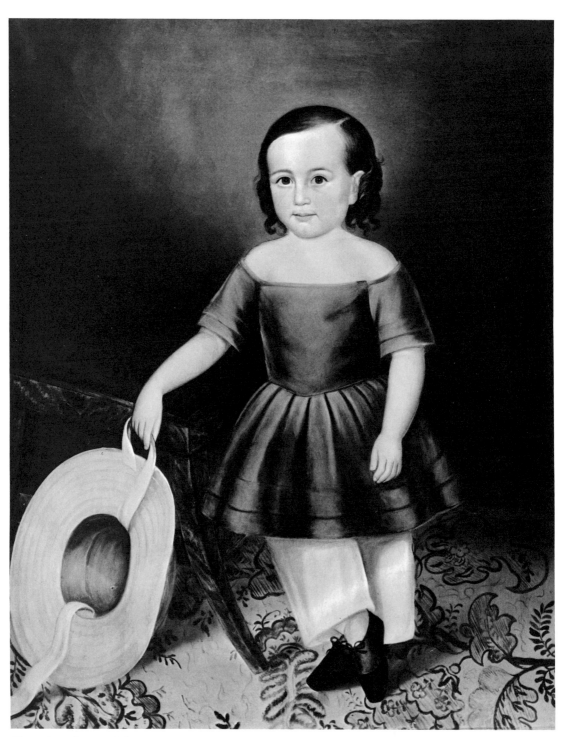

Theodore Besse [I:35]

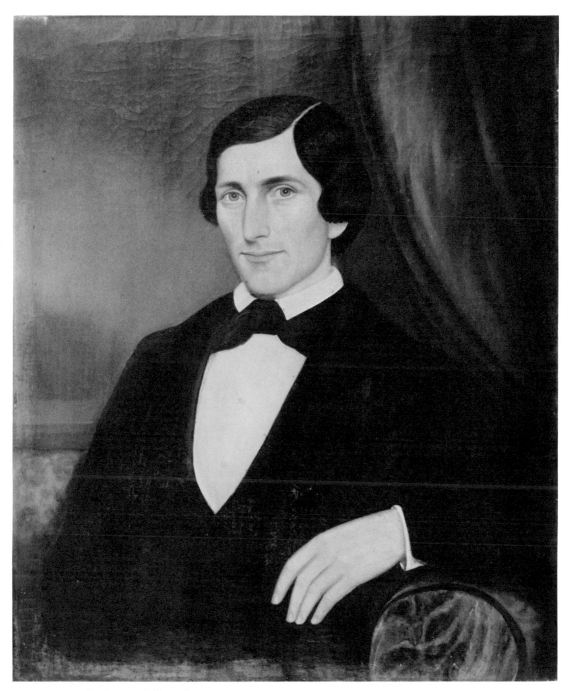

Humphrey H. Soule [I:36]

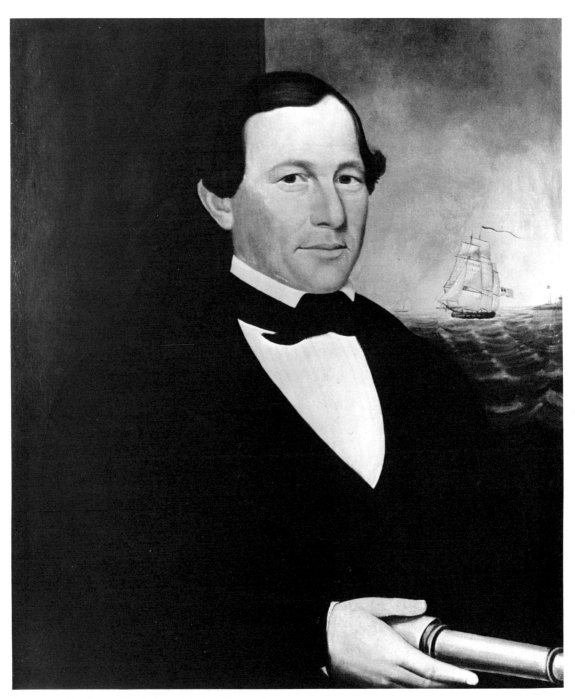

Captain Stephen Christian [I:37]

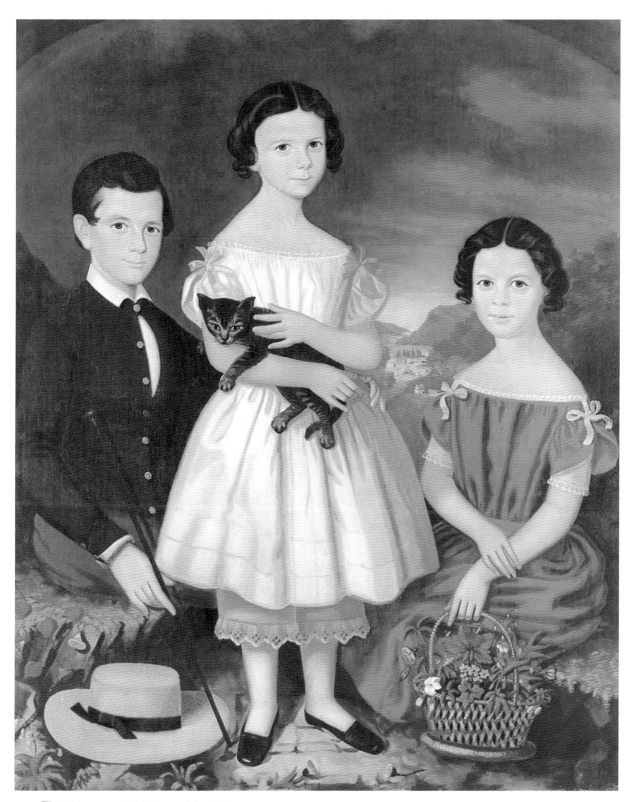

The Farnum Children [I:40]

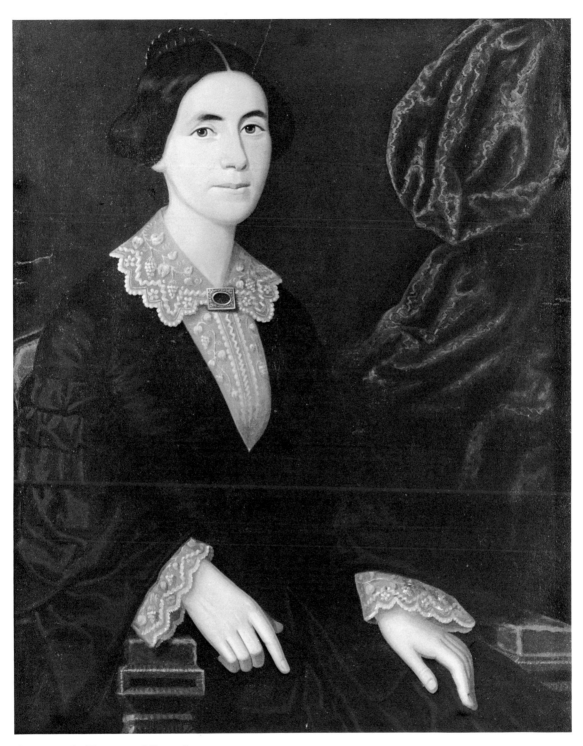

Asenath C. Farnum [I:38]

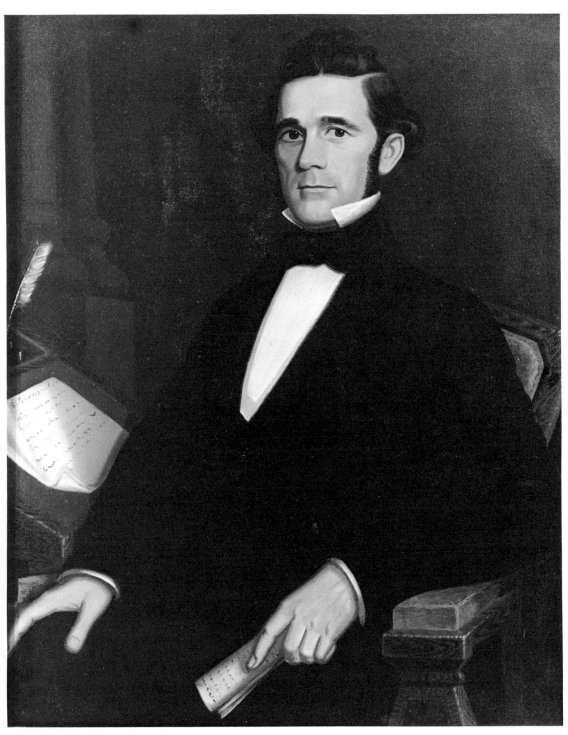

Samuel B. Farnum [I:39]

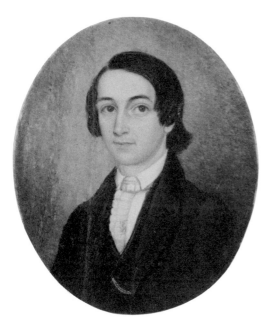 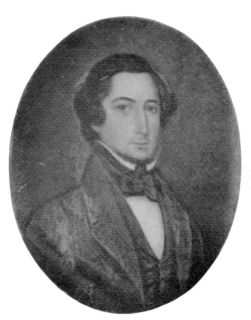

John Houle [I:41] *William Reed* [I:42]

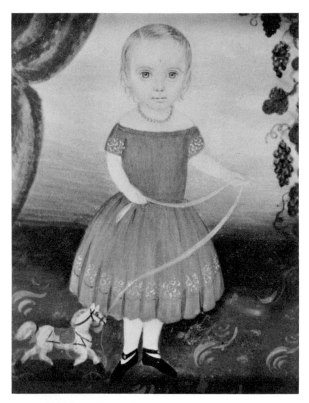

Child in Red Dress [I:43]

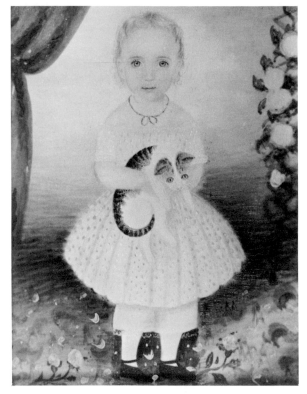

Child in White Dress [I:44]

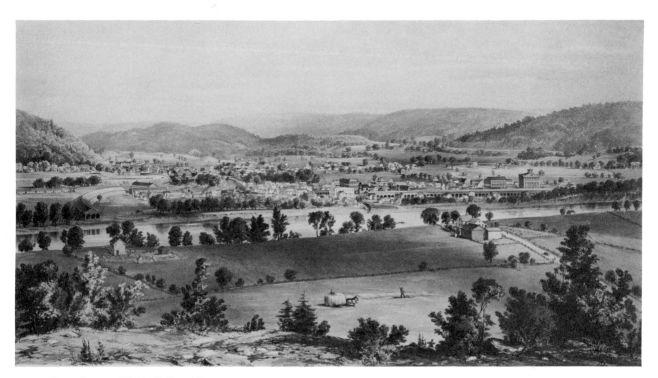

Port Jervis N.Y. [I:45]

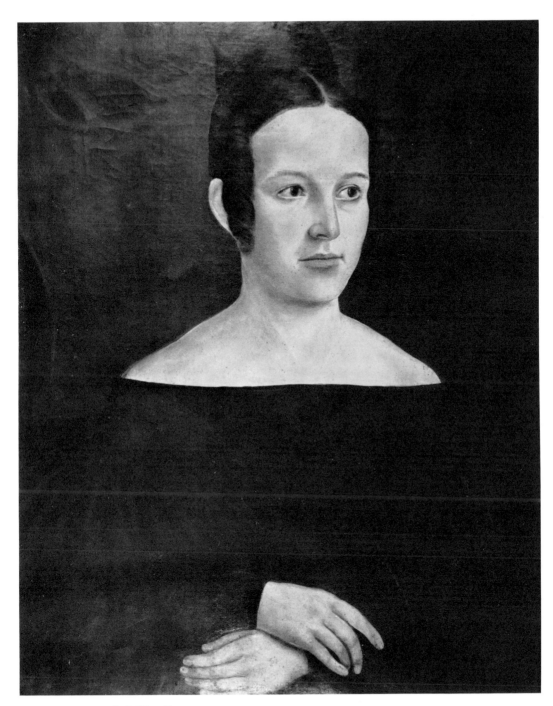

Roxana Merrick [II:1]

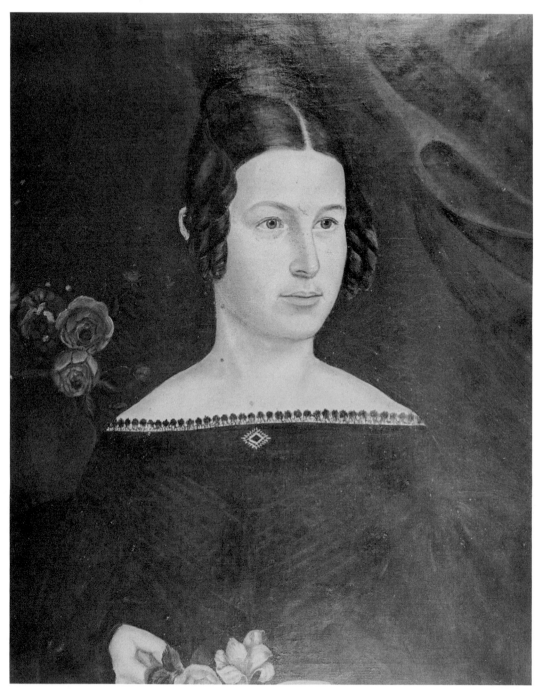

Unknown Woman of the Merrick Family [II:2]

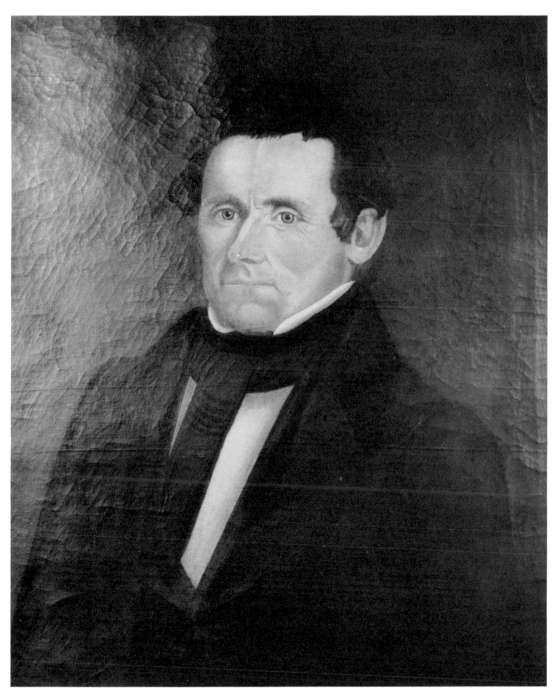

Unknown Man of the Root Family [II:3]

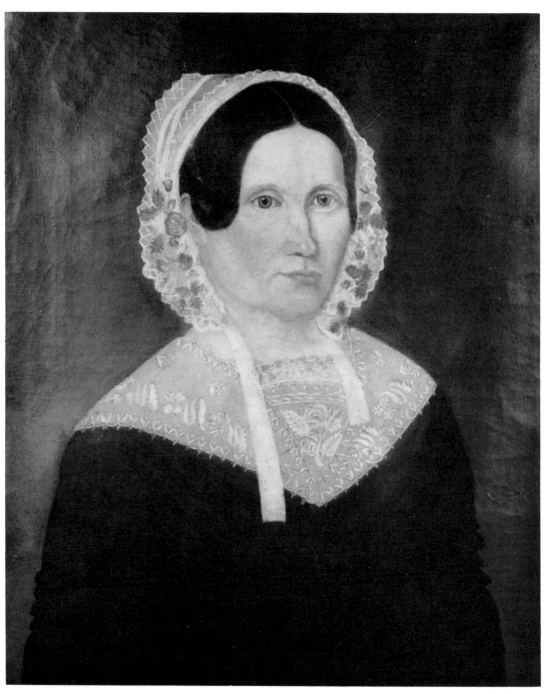

Unknown Woman of the Root Family [**II:4**]

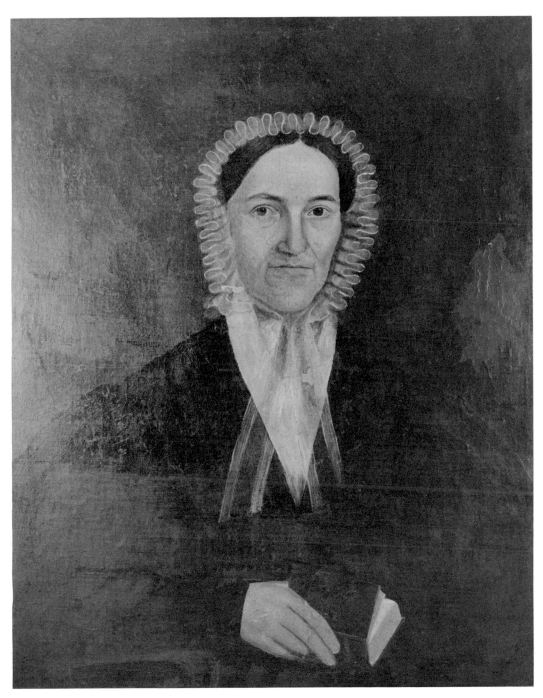

Phoebe Bliss [II:5]

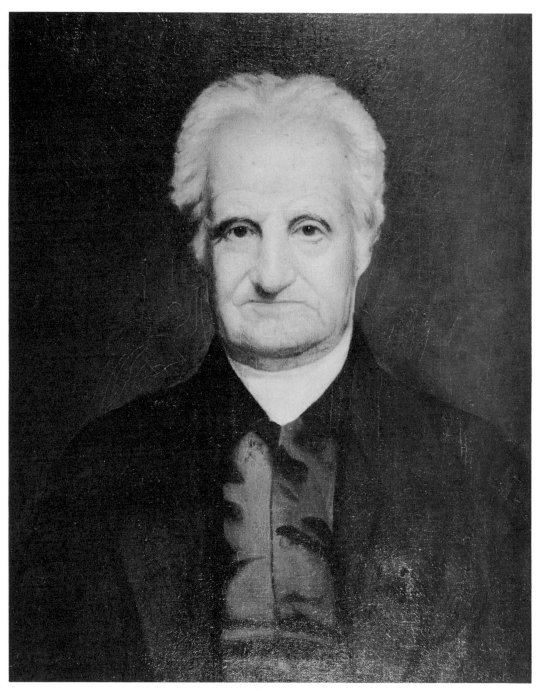

Abraham Avery [II:6]

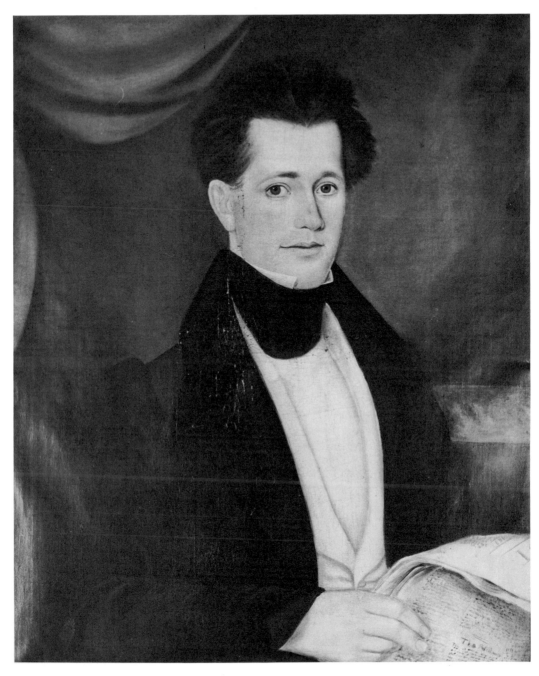

Unknown Man [II:7]

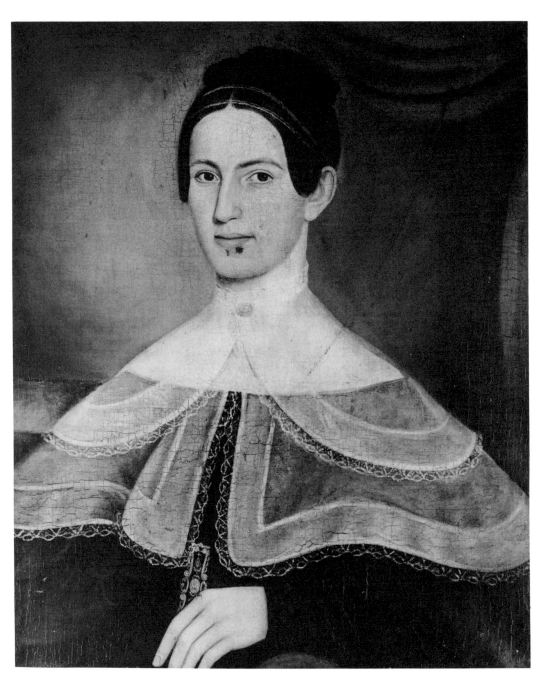

Unknown Woman [II:8]

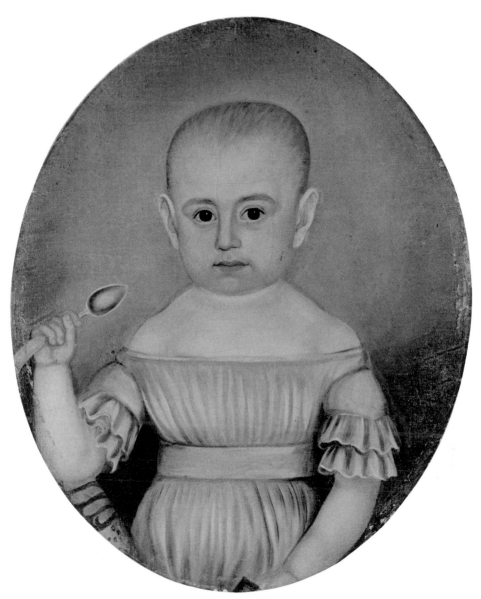

Child with a Spoon [II:9]

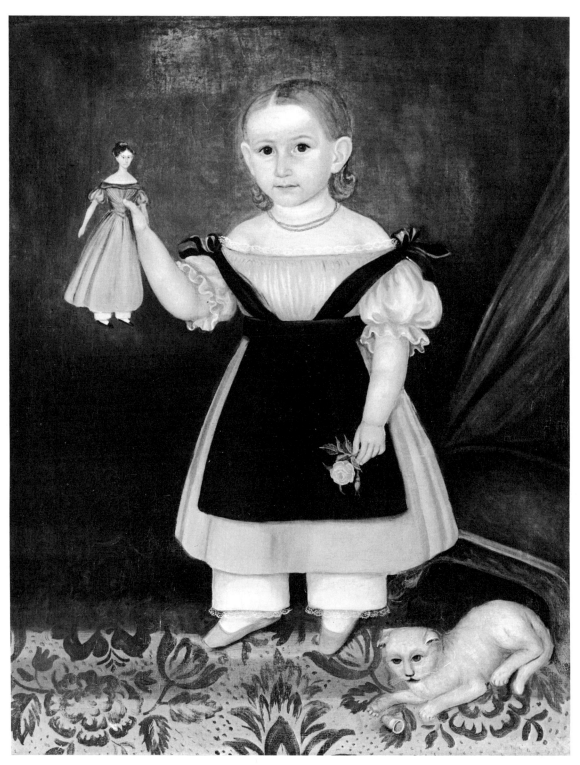

Miss Gilmore [II:10]

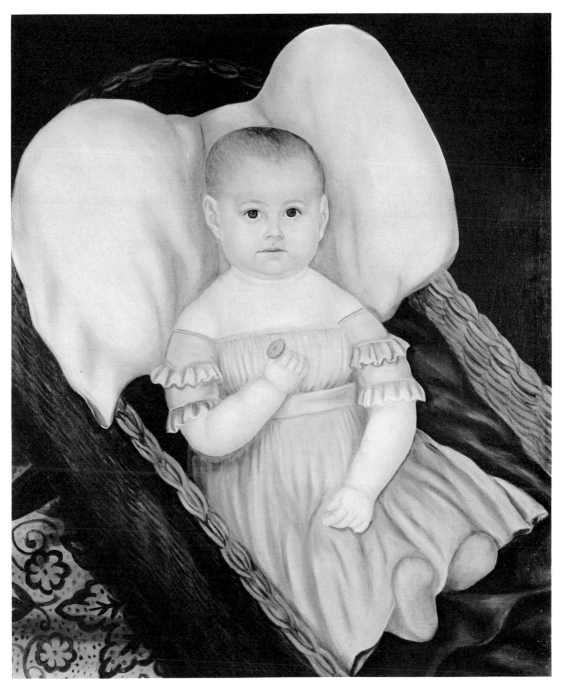

Baby in a Wicker Basket [II:11]

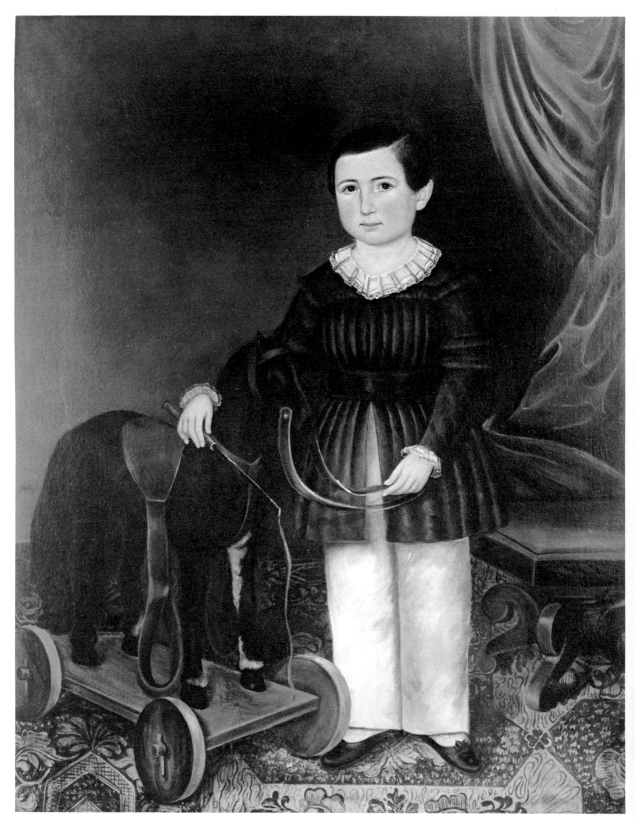

Boy with a Toy Horse [II:12]

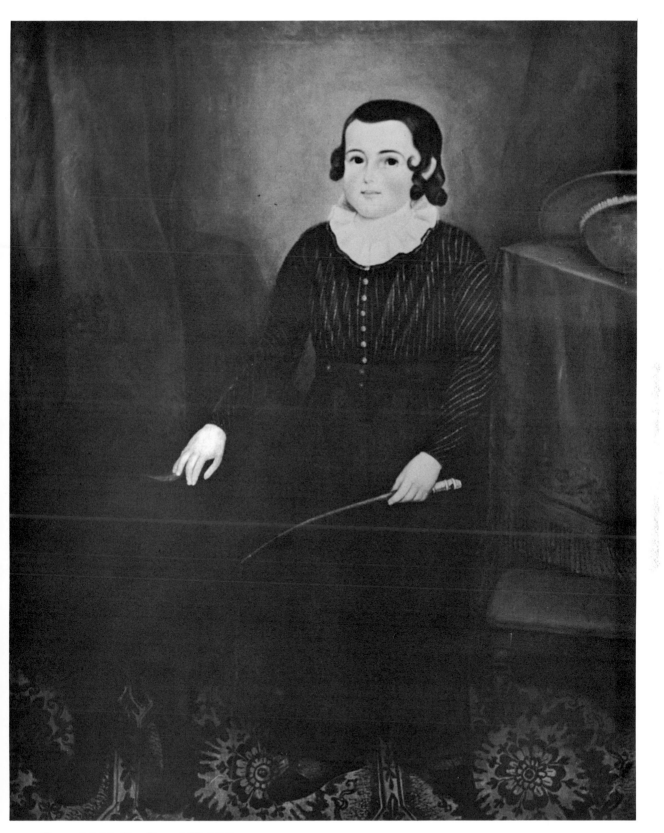

Boy with his Pet Dog [II:13]

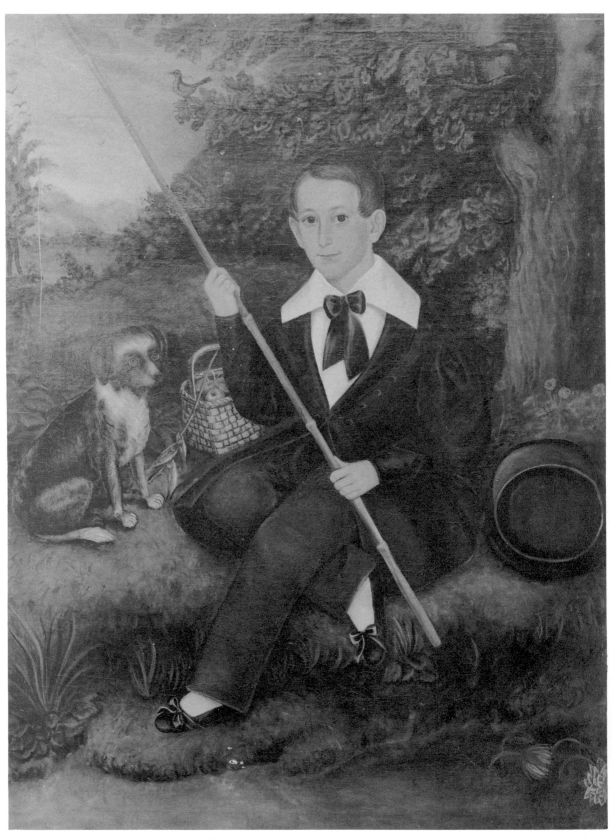

The Fisherman with His Dog [II:14]

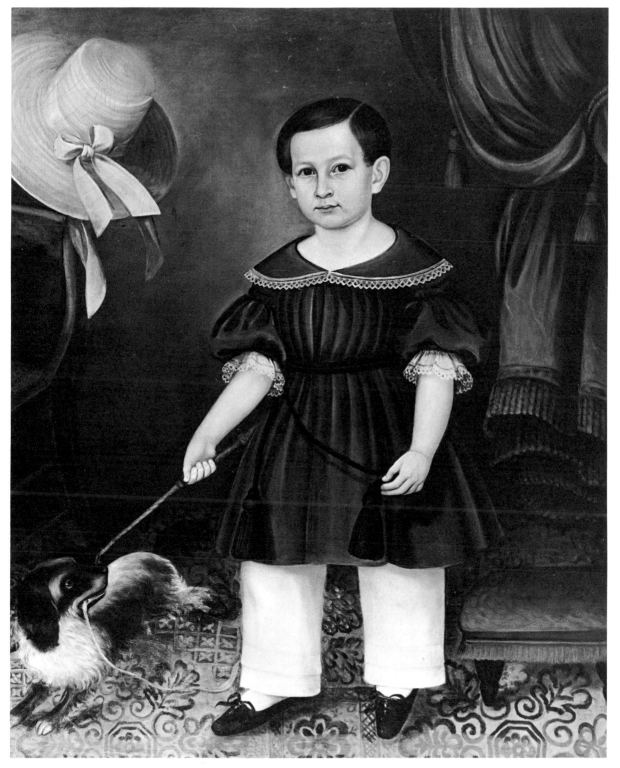

Unknown Boy in a Blue Dress [II:15]

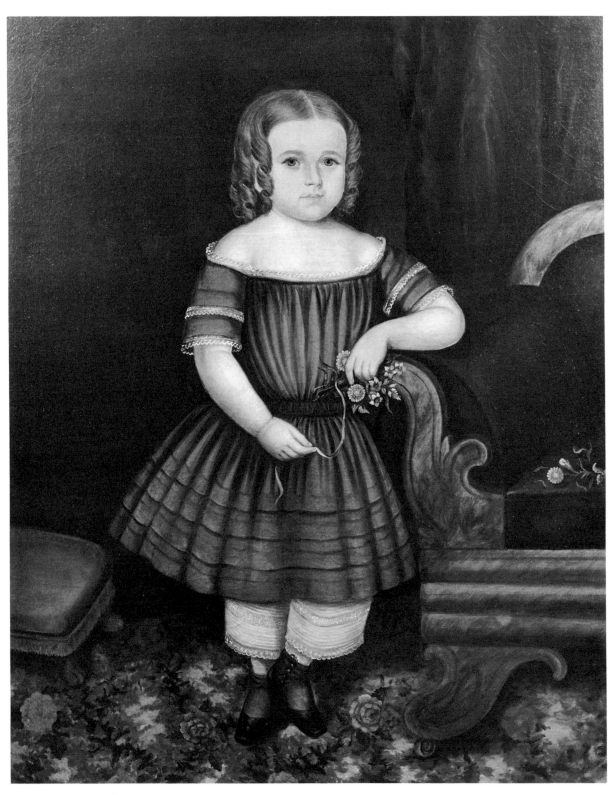

Nancy Riley [II:16]

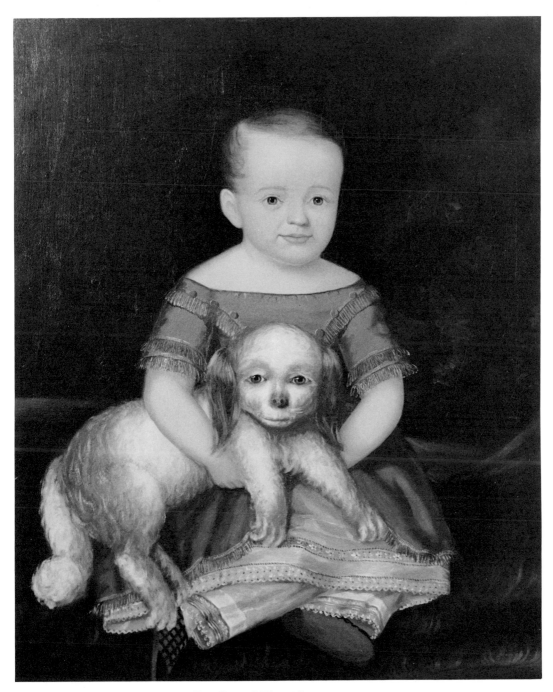

Girl in a Blue Dress with Her Pet Dog [II:17]

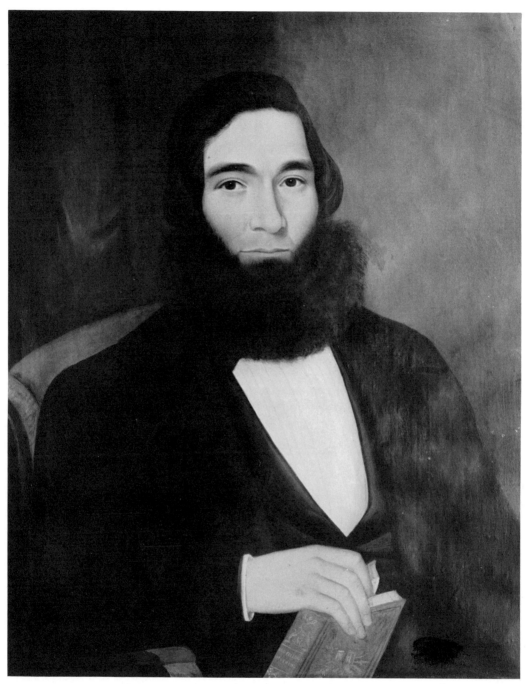

Unknown Bearded Man [II:18]

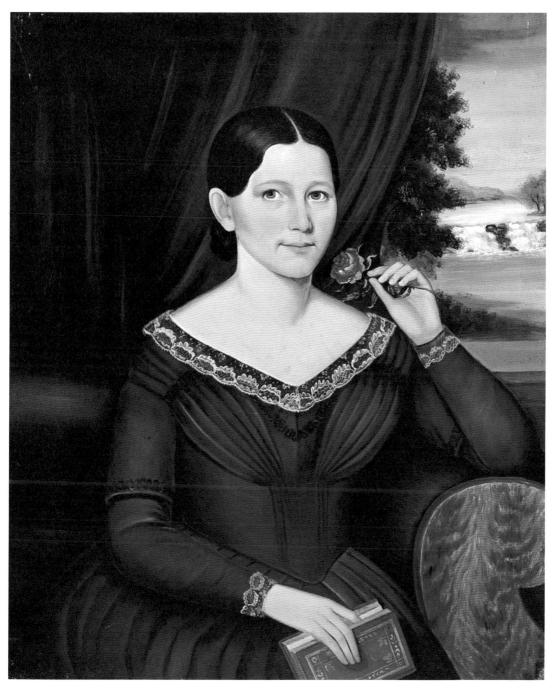

Miss Thayer [II:21]

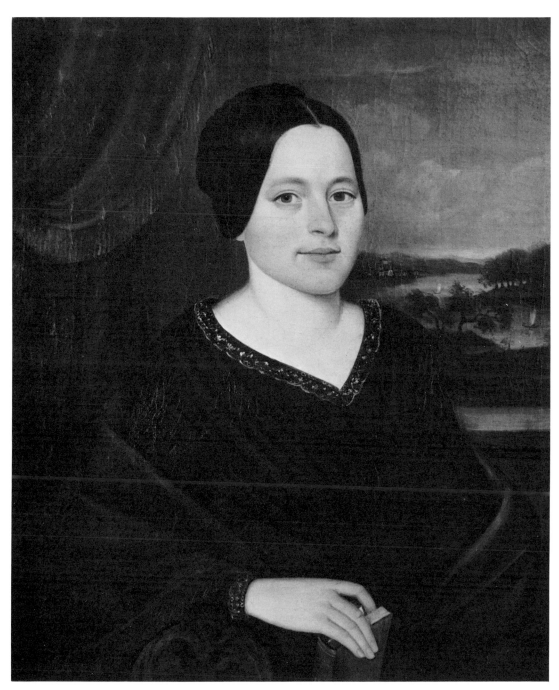

Mrs. Eliza S. Clapp [II:19]

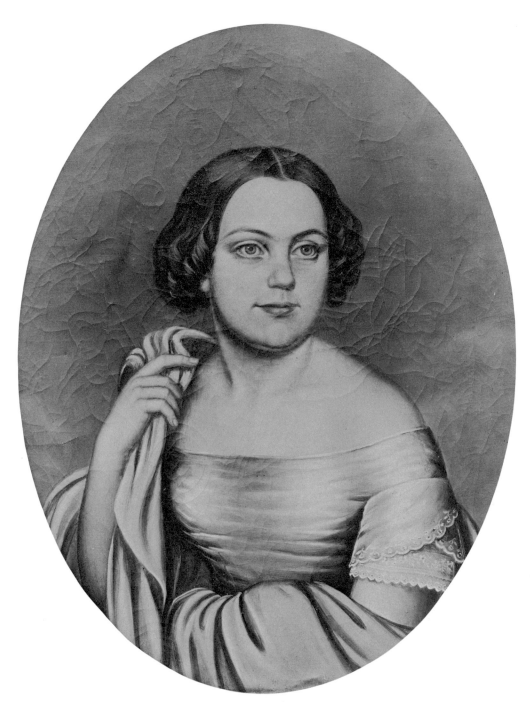

Unknown Woman [II:20]

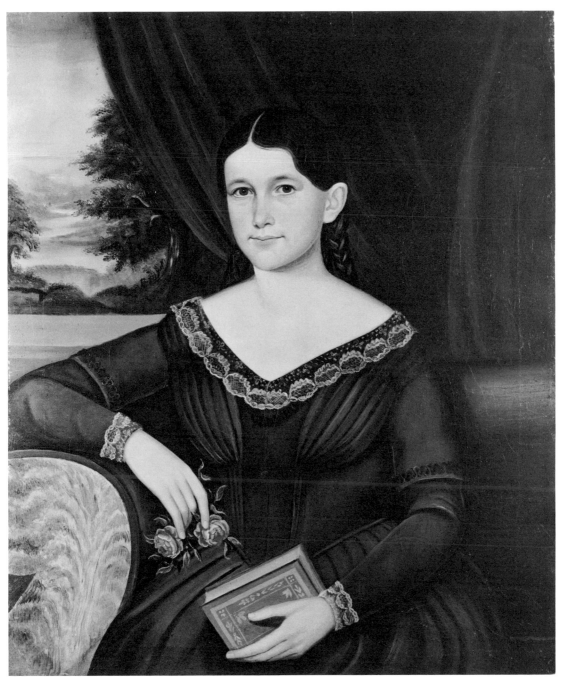

Miss Thayer [II:22]

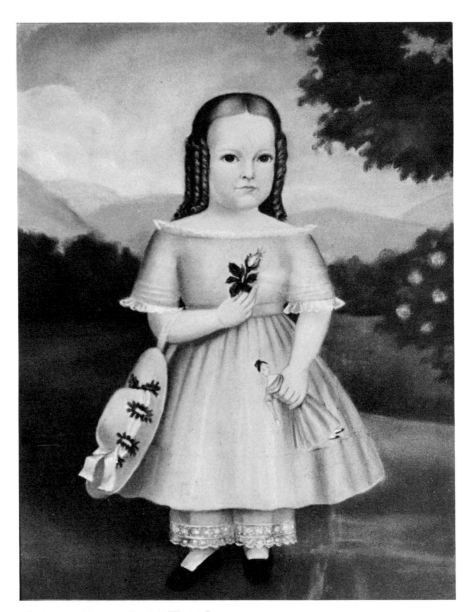

Unknown Young Girl [II:23]

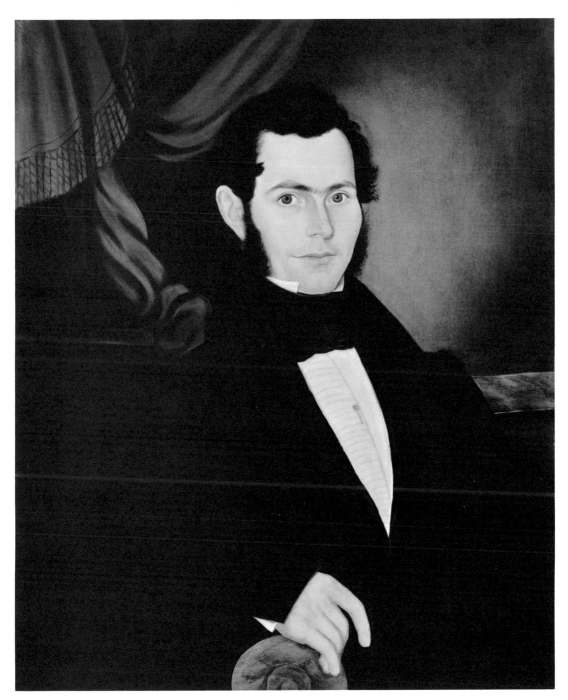

Daniel Plumb [II:24]

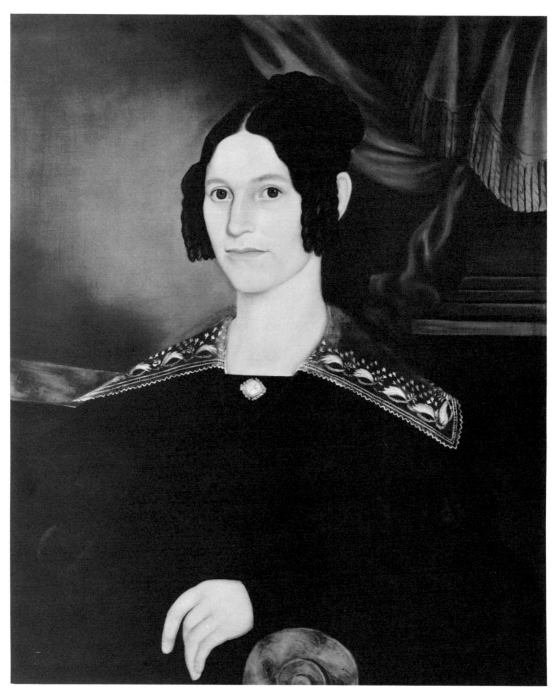

Mrs. Daniel Plumb [II:25]

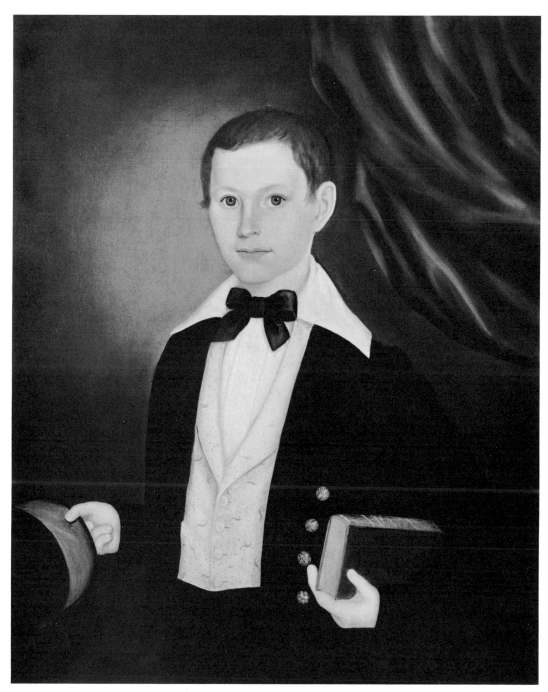

Daniel Plumb, Jr. [II:26]

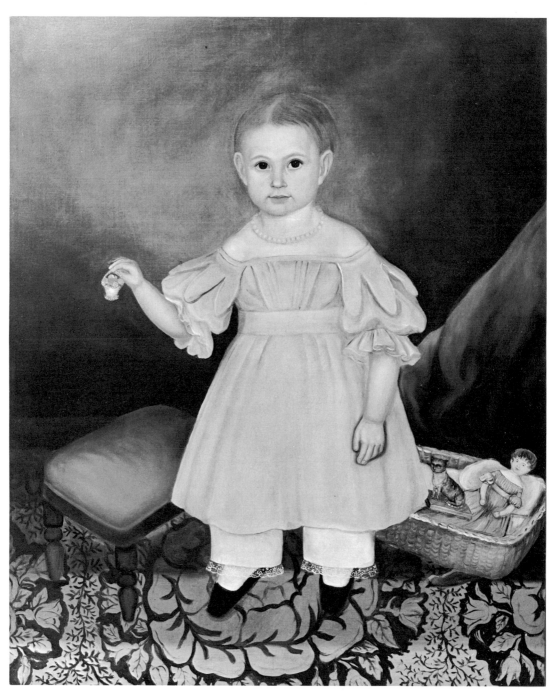

Girl in Pink Dress [II:27]

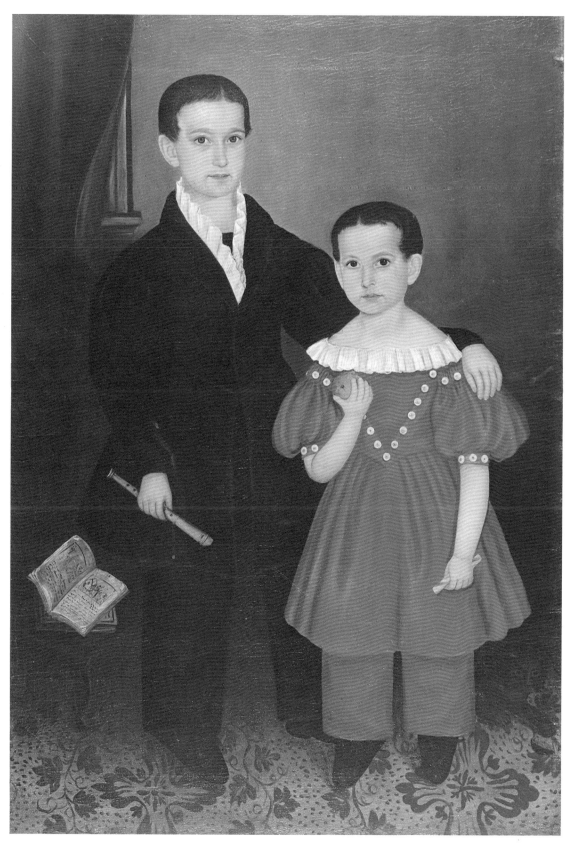

The Blaksley Boys [II:28]

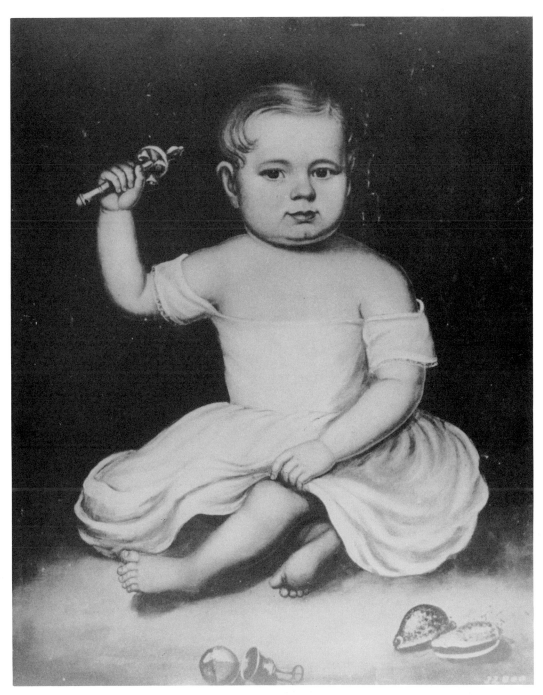

Seated Baby with Rattle [II:29]

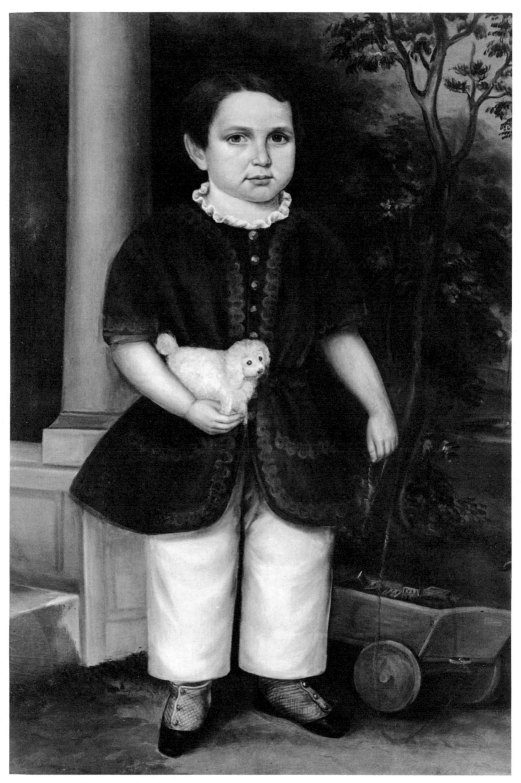

Horace Wilson Eddy [II:30]

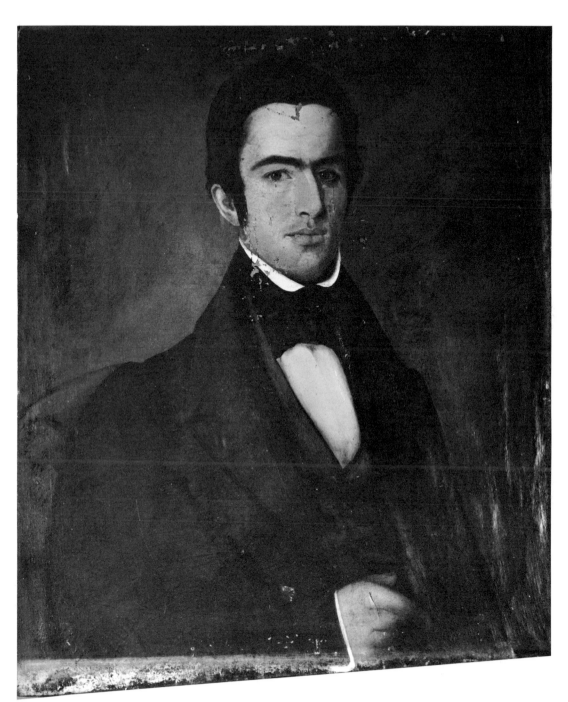

Unknown Man [II:31]

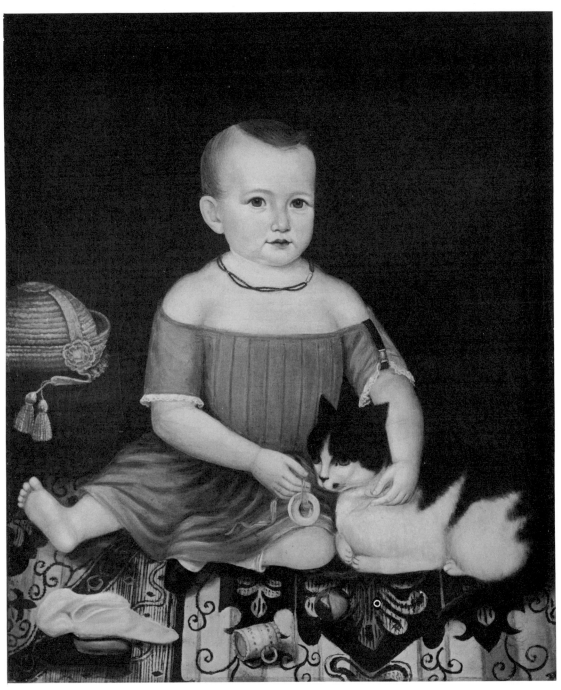

Seated Baby with Cat [II:32]

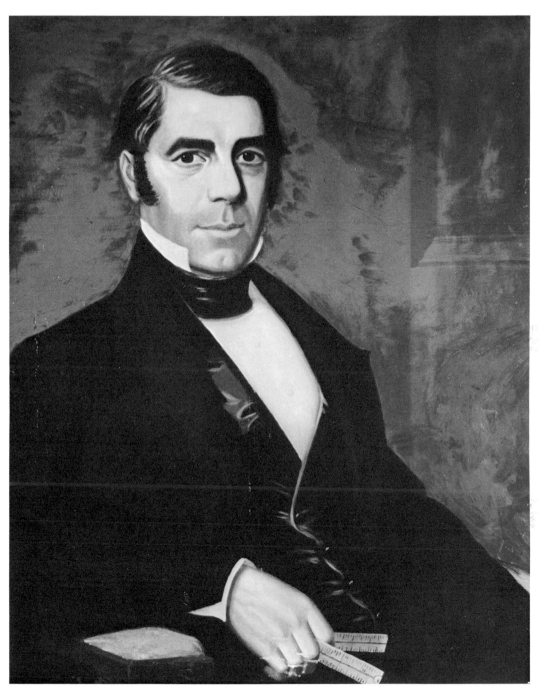

Edward C. Corwin [II:33]

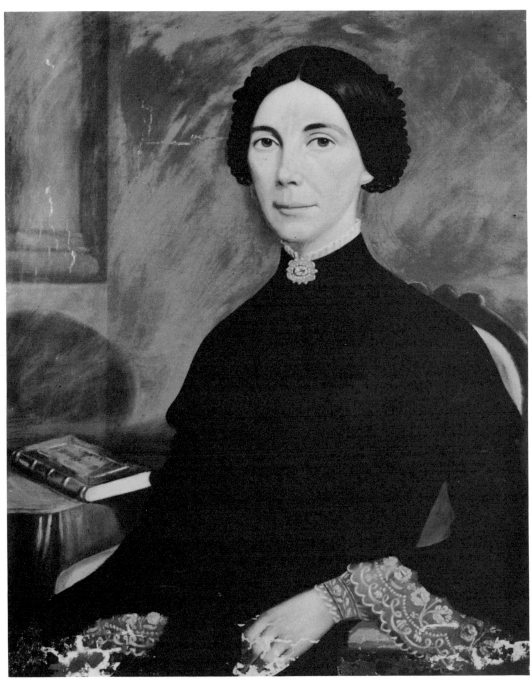

Mrs. Edward C. Corwin [II:34]

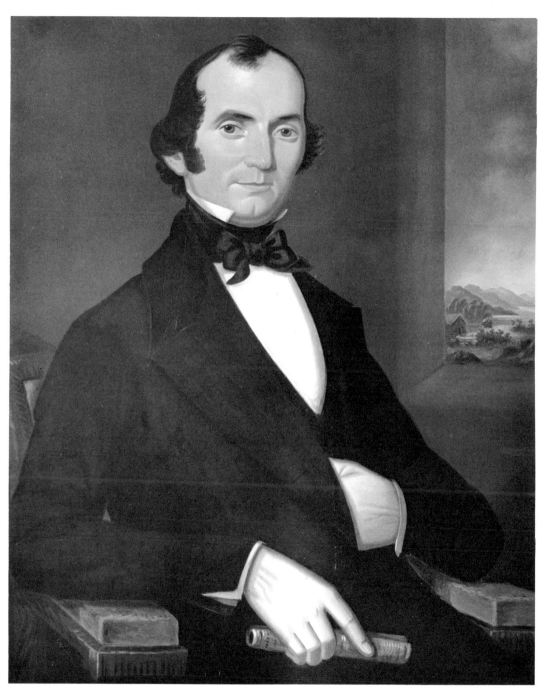

William N. Coleman [II:35]

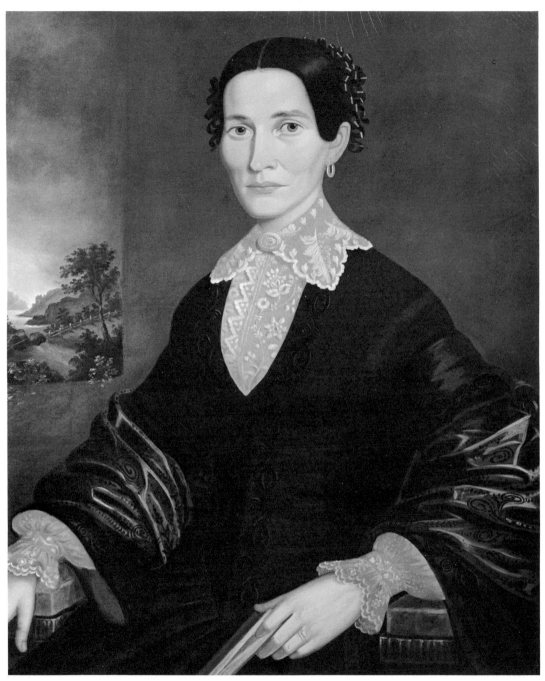

Margaret E. Coleman [II.36]

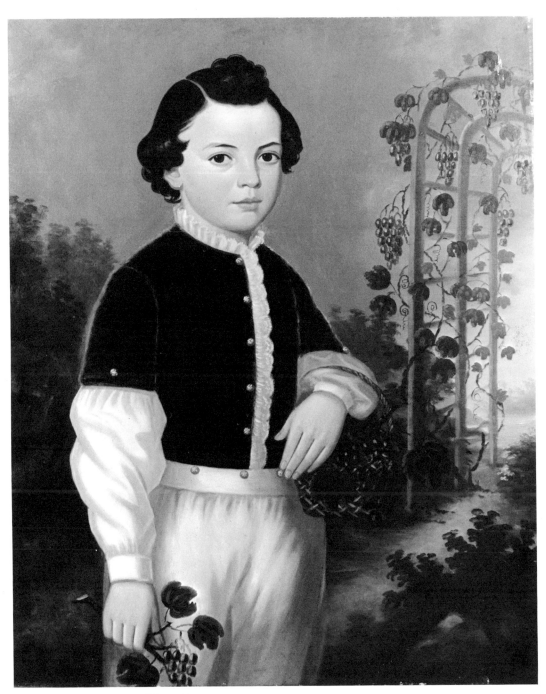

Olever B. Coleman [II:37]

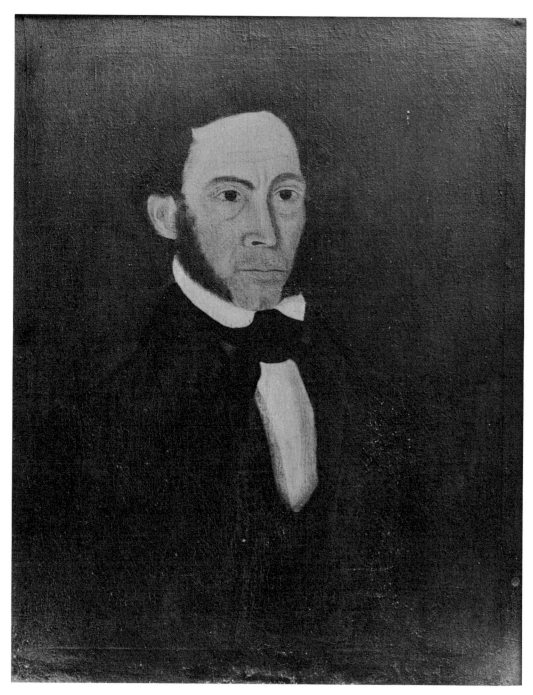

Portrait of a Man [II:38]

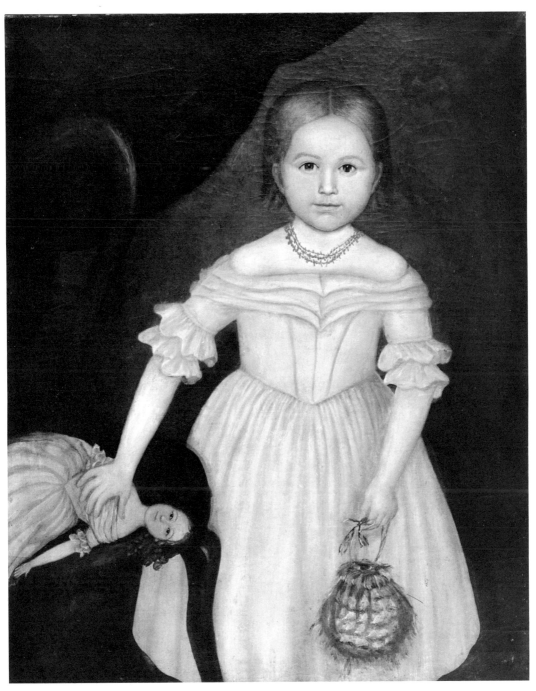

Miss Clark [II:39]

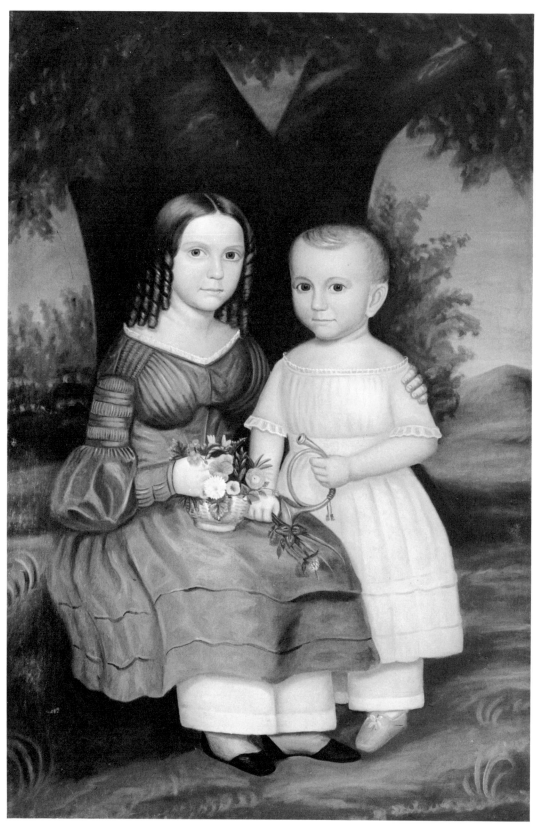

Roxanne C. and Charles Carroll Ray [II:40]

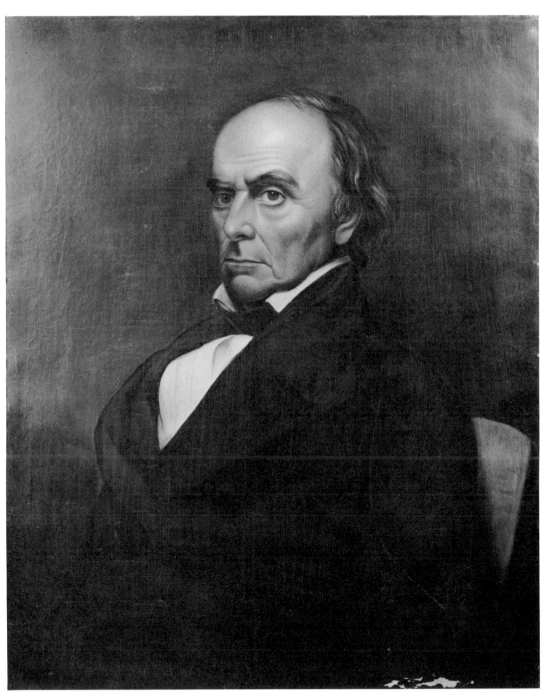

Daniel Webster [II:41]

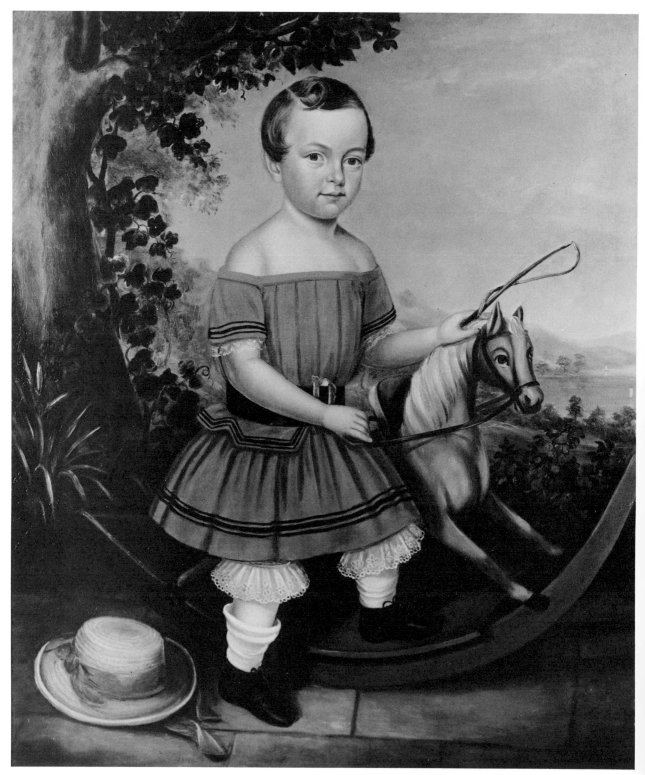

Edmund Seely [II:42]

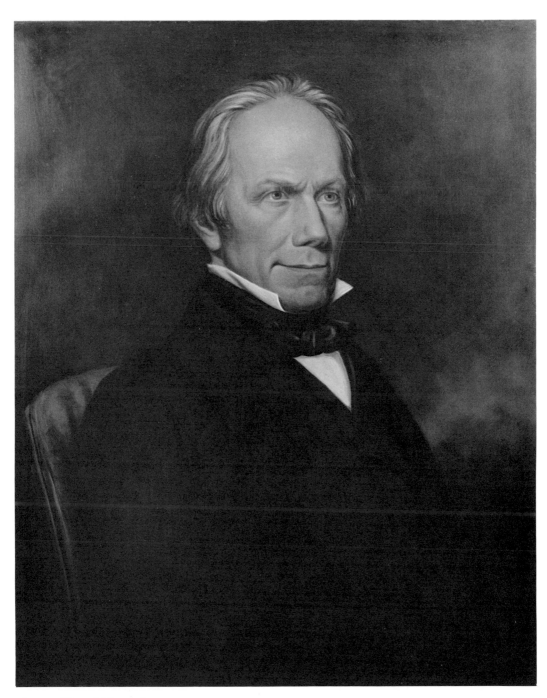

Henry Clay [II:43]

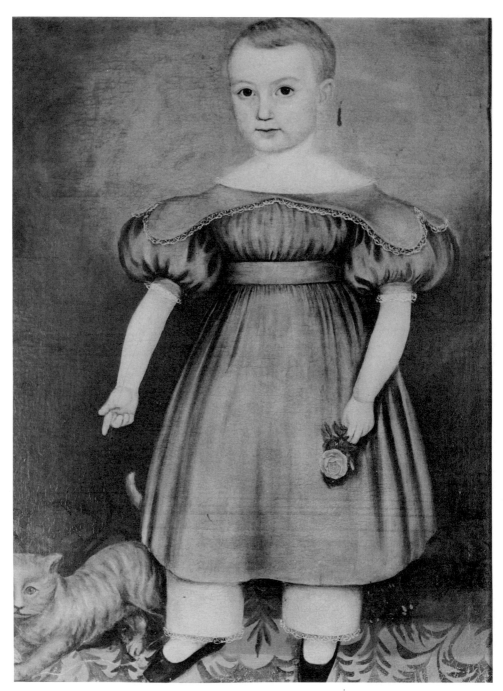

Child with Cat [II:45]

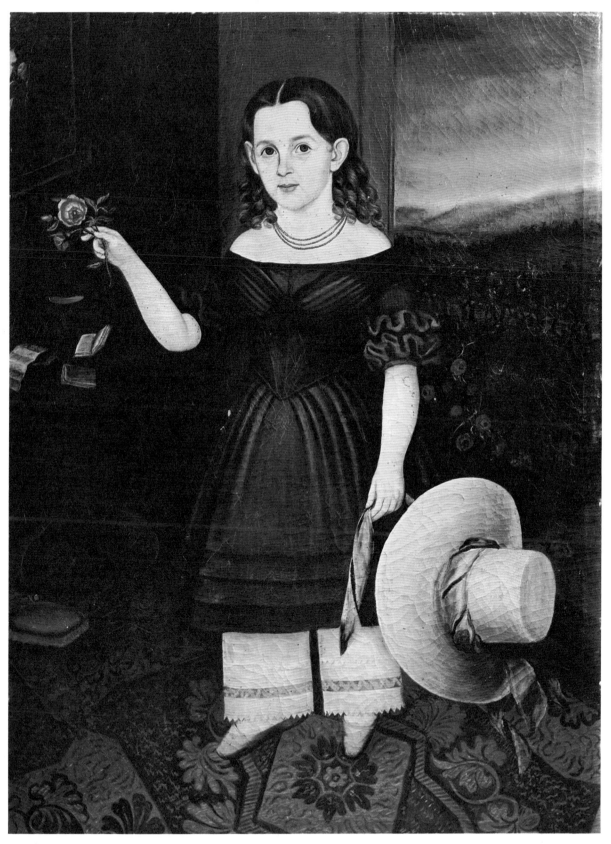

Martha Randall [II:44]

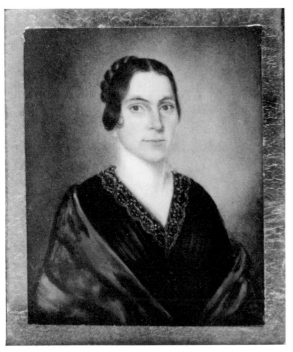

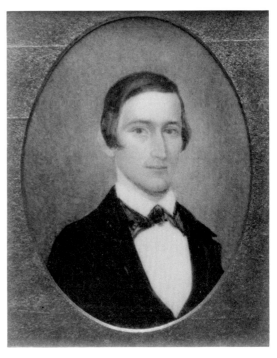

Unknown Young Woman [II:46]

Unknown Young Man [II:47]

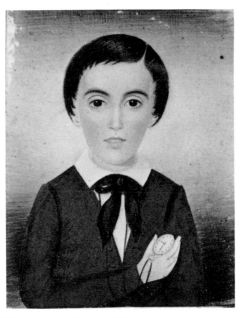

Unknown Young Man
with a Pocket Watch [II:48]

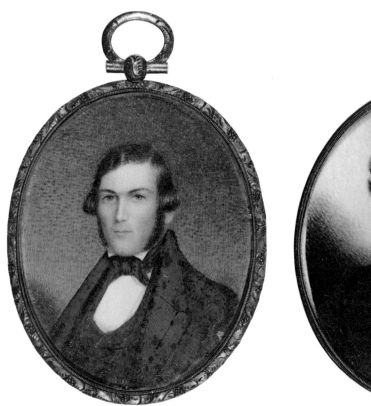 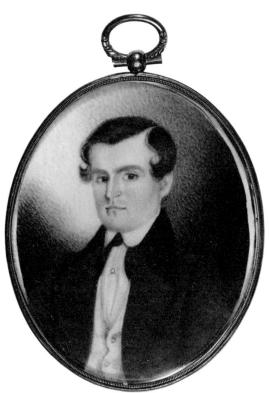

Unknown Man [II:49] *Unknown Man* [II:50]

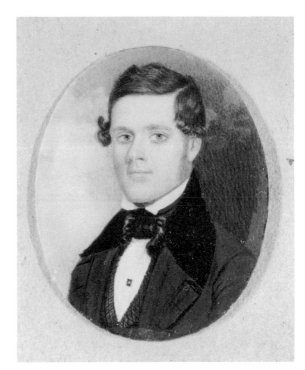

Unknown Man [II:51]

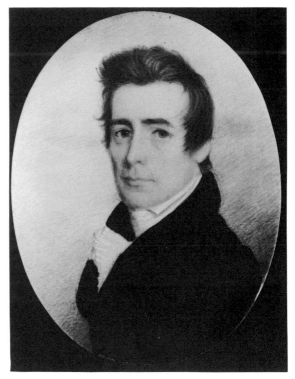

Unknown Man [II:52]

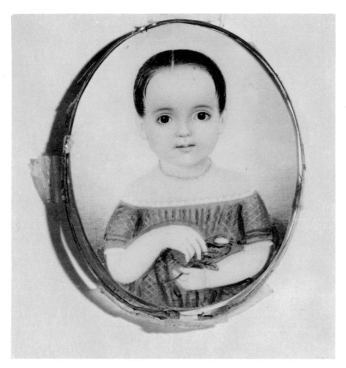

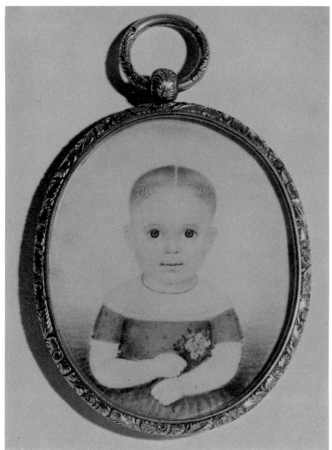

Above: *Young Child* [II:53];
below: *Young Child* [II:54]

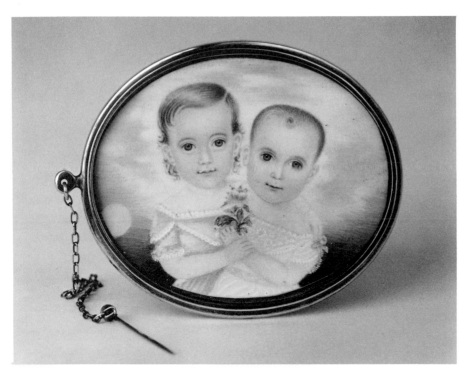

Two Children [II:55]

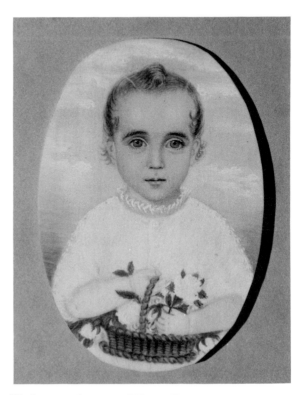

*Unknown Child in White Dress
Holding Flowers* [II:56]

SELECTED BIBLIOGRAPHY

Balderston, Caroline G. *The Image of the Child Before the Civil War: Joseph W. Stock, A. Bronson Alcott and Nathaniel Hawthorne.* An unpublished honors dissertation, Radcliffe College, 1966.

Black, Mary Childs, and Jean Lipman. *American Folk Painting.* New York City: Clarkson N. Potter, 1966.

Clarke, John Lee, Jr. "Joseph Whiting Stock, American Primitive Painter" in *Antiques*, August, 1938 (Vol. 34, pp. 83–84).

Ford, Alice. *Pictorial Folk Art: New England to California.* New York City: Studio Publishers, 1949.

Lipman, Jean. *American Primitive Painting.* New York City: Oxford University Press, 1942.

Little, Nina Fletcher. *The Abby Aldrich Rockefeller Folk Art Collection.* Boston: Little, Brown, 1957.

Rovetti, Paul. *The Journal of Joseph Whiting Stock.* An unpublished master's dissertation, The State University of New York at Oneonta, 1971.

Swan, James, M.D. "Luxation of the Last Dorsal Vertebra . . ." in *The Boston Medical and Surgical Journal*, 25 March, 1840 (Vol. XXII, No. 7).

INDEX